ALDERSHOT'S MILITARY HERITAGE

Paul H. Vickers

To Gillsie,
With best wishes,

Paul H. Vickers

11/12/18

AMBERLEY

First published 2017

Amberley Publishing
The Hill, Stroud
Gloucestershire, GL5 4EP

www.amberley-books.com

Copyright © Paul H. Vickers, 2017

Logo source material courtesy of Gerry van Tonder.

The right of Paul H. Vickers to be identified as the
Author of this work has been asserted in accordance
with the Copyrights, Designs and Patents Act 1988.

ISBN 978 1 4456 6590 0 (print)
ISBN 978 1 4456 6591 7 (ebook)

British Library Cataloguing in Publication Data.
A catalogue record for this book is available from the
British Library.

Origination by Amberley Publishing.
Printed in Great Britain.

Contents

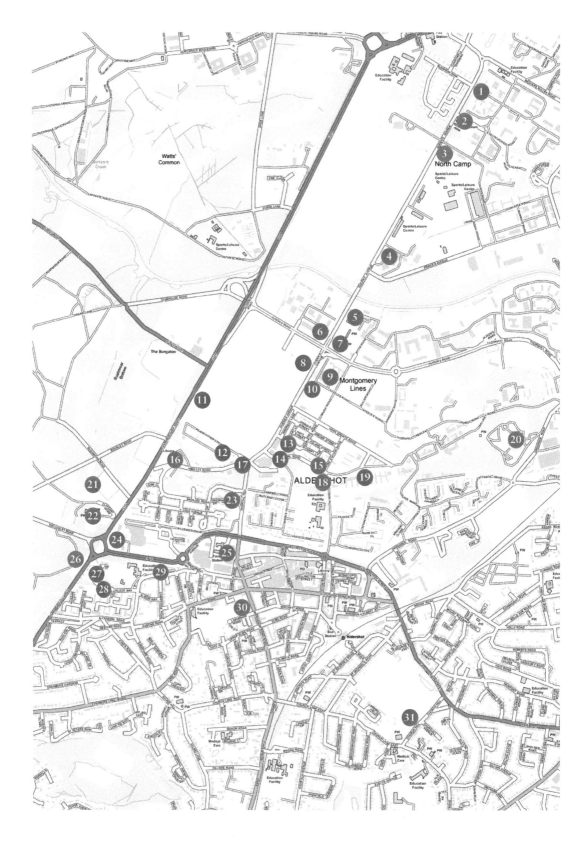

Key

1. Ramilles Copse
2. Aldershot Military Museum
3. Wavell House
4. Fox Gymnasium
5. St Andrew's Garrison Church of Scotland
6. Cammell Memorial
7. Church of St Michael and St George
8. Alexander Observatory
9. Aldershot Command Headquarters building
10. 8th Division Memorial
11. Beresford Memorial
12. Memorial to victims of the IRA bomb
13. Maida Gymnasium
14. Smith-Dorrien House
15. The Gordon Oak
16. Prince Consort's Library
17. 2nd Division Memorial
18. Royal Army Medical Corps Memorial
19. Cambridge Military Hospital
20. Aldershot Military Cemetery
21. Great Wellington Statue
22. Royal Garrison Church of All Saints
23. Union Building
24. Willems Barracks Gates
25. Aldershot Second World War Memorial
26. Royal Pavilion Guardroom
27. Beaumont Barracks Gates and Guardrooms
28. Beaumont Barracks Riding School
29. Veterinary Stables (Beaumont Village)
30. Aldershot First World War Memorial
31. Heroes' Shrine

Introduction

'Welcome to Aldershot - Proud to be the Home of the British Army.' This message, seen on all the approaches to Aldershot, leaves the visitor in no doubt that Aldershot is a town whose history is inextricably linked with that of the military, and that its people take great pride in their long association with the Army.

Aldershot has been shaped by the presence of the Army since it was selected as the site of Britain's first permanent training camp, with unprecedented numbers of soldiers in times of peace. Entrepreneurs quickly saw opportunities for profit and shanty towns sprang up to the north and south of the camp, selling all kinds of goods and services. As it became clear that the Army was in Aldershot for the long term, these temporary buildings were replaced by a new Victorian town centre, much of which survives to the present day.

At its height at the beginning of the twentieth century, Aldershot Camp contained around 17,000 uniformed personnel, together with their dependants and civilian workers. The name of Aldershot became synonymous with the Army, and probably every regiment has been stationed in Aldershot at some time in its history. Today the Army presence is around 5,000 personnel, plus families, and the area occupied by the garrison is around half of that of the Edwardian era. However, Aldershot remains at the heart of the modern Army. There are resident units of guards, infantry and support services, together with a number of training centres; it is also the headquarters of the national Home Command, 11th Infantry Brigade and 101st Logistic Brigade. The Army School of Physical Training is here, as it has been since 1860, and Aldershot is the Army's proud 'Centre of Sporting Excellence'. Demonstrating the military's continuing commitment, between 2006 and 2014 a huge investment was made in modern accommodation, making it fit for an Army of the twenty-first century.

This book is a celebration of Aldershot's rich and continuing military heritage. In following the development of the camp it reveals the immense contribution Aldershot has made to the British Army from the 1850s to the present, including some of the colourful personalities who have left their mark on it, together with the many fine buildings and memorials that remind us of our military predecessors to whom we owe so much.

1. The Camp at Aldershot

In early 1853, two Grenadier Guards officers, Major Higginson and Lieutenant-Colonel Hamilton, were ordered to inspect various heaths and wastelands to assess their suitability for a 'camp of exercise' for the Army. Higginson was sent to survey the area around Chobham, while Hamilton was ordered to look at 'the country south of Farnborough and extending across the canal to a village called Aldershot' – a small rural village with a population of only 875, who mainly earned their living from agriculture.

The desire for a 'camp of exercise' grew out of attempts in the 1850s to modernise the British Army. By the middle of the nineteenth century the Army urgently needed to update its organisation, weapons and training. For some time a group of army reformers had been aware that action was needed, but the Duke of Wellington had blocked any changes to the army that had won Waterloo. Following Wellington's death in 1852, the reformers began their work, giving priority to training troops in large formations. The Army was scattered in small pockets around the country, billeted in the coastal defences, in large towns and cities where they were used to keep public order, and in civilian houses. The proposal for a camp where entire divisions could be brought together, exercised and manoeuvred was a first attempt to remedy this problem.

The site chosen for the 1853 exercises was Chobham, despite Major Higginson's view that the area was too boggy and without any fit drinking water. From 14 June around 10,000 men, infantry and cavalry, mustered on Chobham Common for drill, field operations and parades. After four weeks the entire force was changed for another division of the same size, which trained until 25 August. The experience of the Chobham Camp showed the importance of this training, and that Higginson had been correct in his assessment of the poor quality of the ground.

In contrast, Colonel Hamilton had reported that the area around Aldershot was 'in every way advantageous'. Lord Hardinge, Commander-in-Chief of the Army, visited it in March and April 1853, and ordered an initial survey of the area by the Royal Sappers and Miners. Even as the Chobham exercises were still underway, Hardinge decided that a permanent training camp was needed and that the heathland at Aldershot was the best option.

Unknown to Hardinge, in August 1853, an Enclosure Act had been passed for a number of tracts of common land, including that around Aldershot. When alerted to the potential loss of Aldershot Heath, Hardinge wrote a memorandum setting out the military reasons why a permanent camp should be established there. He explained the advantages of concentrating a large number of troops in a suitable location, including the economic benefits of a dedicated training camp, and he concluded that the camp 'would be of the greatest value in case the country should be threatened by a war of invasion'. For Hardinge, Aldershot was strategically 'one of the most important points that could be selected.

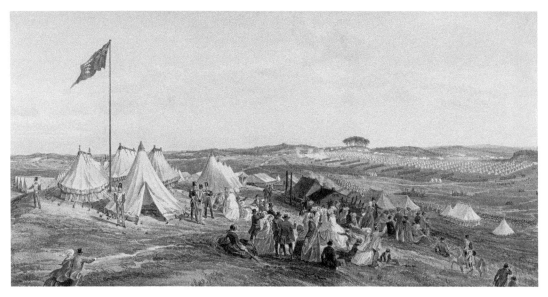

The Camp at Chobham, 1853. (PCL)

Long Valley in 1856, typical of the country of Aldershot Heath. (PCL)

It has an ample supply of water at all seasons. This tract of land is therefore suited for a permanent camp of instruction in peace, and of concentration in war.'

The Prince Consort supported Hardinge's proposals, and in December the Treasury authorised £100,000 for buying land at Aldershot. The main landowner, Mr Samuel Eggar, agreed to sell 2,000 acres of Aldershot Heath for £12 an acre. For the smaller landowners and commoners to make their case, meetings were held at the Red Lion Inn for anyone claiming rights in Aldershot Common.

Towards the end of April, 4,000 acres had been bought out of the 6,000 acres needed, but some landowners held out in the expectation of a better price. However, because Hardinge's memorandum had emphasised Aldershot's strategic location, the Treasury solicitors ruled that the land was needed 'for the defence of the Realm' and so allowed compulsory purchase warrants to be served on the dissenting landowners.

On 27 March 1854, Britain had declared war on Russia and the regular army was despatched to the Crimea. With the regular forces overseas, the government called out the militia, and by the end of 1855 some 50,000 were under arms. The lack of barracks posed an acute problem, and many militia had to be billeted on the civilian population, making the need for a new camp at Aldershot ever more urgent.

In April 1854, a party of Royal Sappers and Miners arrived in Aldershot to carry out a detailed survey of the heath and pitched their camp on some spare ground to the south, now the site of Princes Gardens. Hardinge was unsure what form the camp should take, and set up a committee to investigate. Their view was 'that the Buildings to be erected at Aldershot should be of a substantial and durable character, having brick walls and slated roofs'. However, such buildings would take a considerable time to complete, and urgent action was needed to alleviate the militia's immediate accommodation problems. As a result, on 17 January 1855 the Board of Ordnance gave orders that contracts were to be let for building wooden huts for the camp at Aldershot.

On 24 February 1855, Lord Hardinge personally 'marked out the ground for 20,000 militia, 12,000 on the south side of the canal and 8,000 on the north'. Messrs Haward and Nixon were awarded the contract to build huts for the North Camp and for 7,000 men in the South Camp, and Mr Hemmings for another 5,000 men also south of the Canal. On 10 March the first load of building materials was brought up the Basingstoke Canal, and on 17 March the Office of Ordnance placed its first order for barrack stores for Aldershot.

As the first huts were finished the troops started to move in, the first arriving in mid-May 1855, and by June it was reported that four regiments of militia were stationed in the camp. Colonel Henry Knollys later recalled that some of the militia were 'the most raw of raw militia regiments whose military manoeuvres were limited to one imperfect formation of fours; some of them drunkenly loping, straggling and swearing into the South Camp huts'. He particularly remembered the 5th Elthorne Light Infantry, Middlesex Militia, which 'had been recruited from the purlieus of Whitechapel and the Seven Dials, and was largely composed of Costermongers and Pickpockets well known to the Police'. However, Knollys also noted that the militias benefited from their time in the camp and 'in 6 months they were trained into steady soldiers'.

The North and South Camps were identical in appearance and layout except that North Camp was slightly smaller. The huts were arranged in lines, lettered from A to Q in North Camp and from A to Z in South Camp. Each line contained thirty-eight huts, plus a brick privy for soldiers and another for officers. Twenty huts were allotted for men's accommodation, one for staff-sergeants, four for officers' accommodation, another for officers' servants, and one large hut acted as an officers' mess. Other buildings included a guard house, orderly room, cookhouse, quartermaster's stores, ablutions, wash house, shoemaker's shop and armourer's shop. Two complete lines made up the accommodation required for a battalion of infantry, including a hut for married soldiers and their wives, a large soldiers' canteen, bread and meat stores, a library and a school.

The men's huts contained twenty-two beds in one large room, with the space for each soldier little more than the width of his bed. On the wall above the bed were some pegs on which he could hang his belts and haversacks, and above these were two shelves on which to store the remainder of his kit. The only heating was a single small coal-fired metal stove.

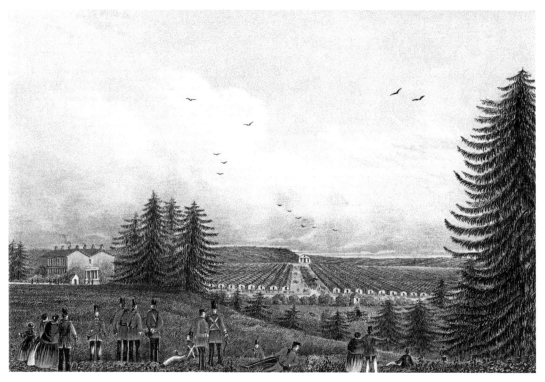

North Camp, *c.* 1857. (AMM)

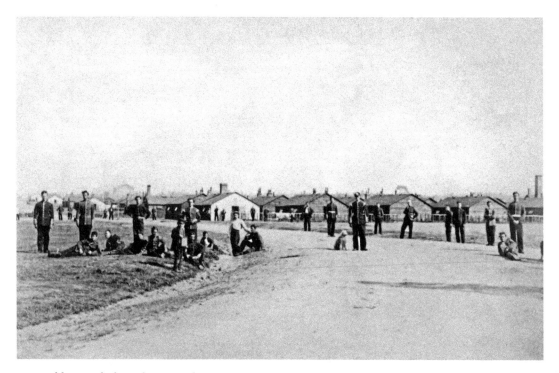

Soldiers in the hutted camp in the 1860s.

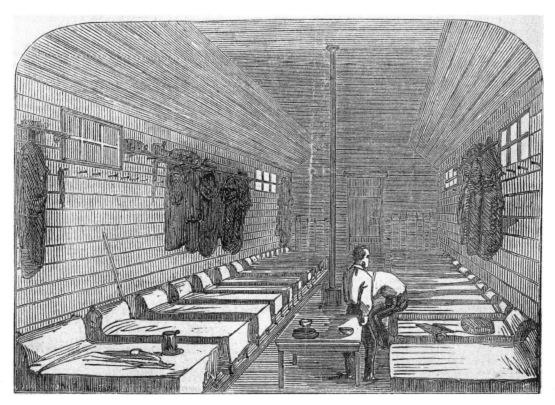

The interior of a soldier's hut. (PCL)

At this time only around 6 per cent of 'other ranks' were permitted to marry, and the married soldiers' hut was identical to that for the single men. Ten men, their wives and children lived in one large room, blankets hung between the beds providing the only privacy.

Externally the officers' huts looked similar to the men's, but inside they were divided into eight rooms, so that each officer had a room to himself with his bed, fireplace, a chair and small table, and a couple of shelves for his kit. Although an improvement on the men's rooms, there was still little comfort or privacy. The anonymous writer of *Sketches of Aldershot* explained that the partitions between rooms were 'so thin, that an officer in No. 2 derives the advantage of hearing nearly everything that passes in Nos. 1 and 3'. One hut accommodated the senior officers, in which two majors enjoyed the luxury of having two rooms each, a bedroom and a sitting room, while in the other half of the hut the battalion's commanding officer (Lieutenant-Colonel) had four rooms.

Although the main effort from 1854 to 1856 was to rapidly build the much needed huts, the original intention to have 'permanent' barracks at Aldershot had not been forgotten. Plans for the infantry barracks were drawn up by Major-General Sir Frederic Smith of the Royal Engineers, who was in charge of building the camp. He sent these to Lord Hardinge, who in turn sent them to the Prince Consort for his approval. Major-General Smith received orders to begin construction on 3 August 1856. To pay for the permanent barracks, an initial sum of £250,000 was agreed by Parliament. By the end of the building project in 1860, the total cost of the permanent barracks had risen to £574,300 (around £63 million today).

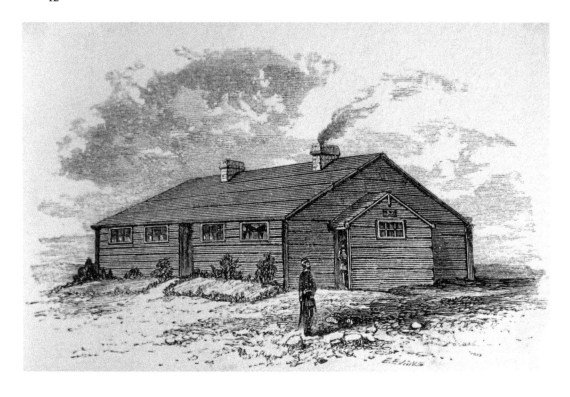

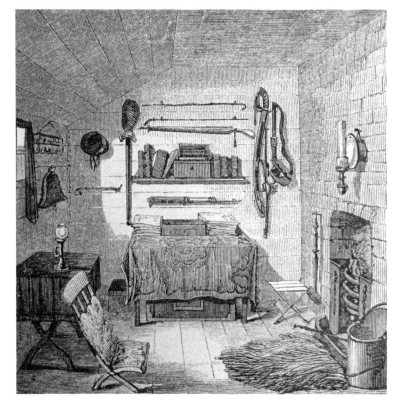

Above: Exterior of an officer's hut. (PCL)

Left: Interior of an officer's room. (PCL)

The building contract was let to George Myers, a well-known builder who had already completed a number of prestigious projects. Three infantry barracks were to be built on the north side of what would become Wellington Avenue, with two artillery barracks to the east and three cavalry barracks to the south.

Henry Wells, who would become one of Aldershot's leading businessmen, came to Aldershot in 1855 on Myers' staff. When interviewed in 1898 about the camp's construction, Wells referred to notebooks he had kept at the time and said that the building of the infantry barracks started on 22 August 1856, with the cavalry barracks in the following July. His notes also recorded that the first regiment to be stationed in the new barracks was the Lancaster Militia, who arrived on 14 December 1857.

By the end of 1859 all the barracks were complete. The cavalry barracks, named simply East, West and South Cavalry Barracks, each contained four large troop stables of two storeys, with stabling for the horses on the ground floor and rooms for the men above. Between the main blocks were the officers' and sergeants' messes. In addition there were a small number of married soldiers' quarters and other necessary buildings such as a riding school, forges, saddlers and stores. The three infantry barracks were likewise just called East, Centre and West Infantry Barracks, and had at their core two large, three-storey men's barrack blocks. There were ten rooms on the upper floors, each accommodating one sergeant and twenty-four men, while on the ground floor were eight accommodation rooms and two kitchens. The two blocks stood 80 feet apart with a glass roof between them, providing an all-weather drill and exercise area. Behind the main blocks were the married soldiers' quarters, with the officers' mess to the side. The artillery barracks, one for horse artillery and one for field artillery, were each arranged around a large square. There were two troop stables in the same style as for the cavalry, similarly with

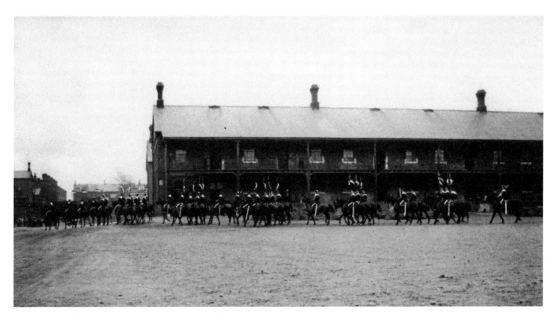

Part of the permanent cavalry barracks.

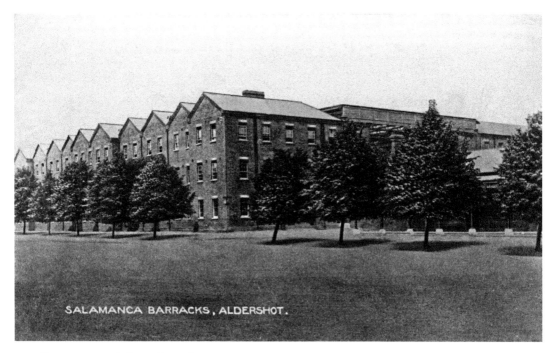

SALAMANCA BARRACKS, ALDERSHOT.

The permanent infantry barracks.

an officers' mess between them. On the opposite side of the square stood two large gun sheds, between which were the married soldiers' quarters, and other buildings included a magazine, armourer's shop, forges, workshops, cookhouse, school and library.

By 1859 there were 15,000 soldiers in the camp, and the effect on Aldershot was profound. The original village was a mile south-east of the camp, but when the Army arrived in strength a new town started to appear immediately to the south of the new barracks, on what had previously been fields of rye and barley. At first entrepreneurs put up simple wooden buildings for shops, laundries, beer halls, public houses and music halls, all designed to relieve the soldier of his pay. When the permanent barracks signalled that the camp was there to stay, the wooden town began to take more permanent shape as the businessmen built in bricks and mortar. Residential streets were built, some for the influx of civilian employees and some, rather smarter houses, for officers who wanted suitable accommodation for their wives and families. To the north of the camp a similar pattern of new building followed.

Life for the soldiers in Aldershot quickly settled into a routine where the days were long and busy. For the cavalry, reveille was at 6 o'clock, and by 6.15 the men had to be at the stables, where the roll was called. The horses needed to be cleaned, watered and fed before the troopers were allowed their breakfast at 8 o'clock. This was followed by three hours of exercises, or riding lessons for recruits, before feeding the horses again, after which the soldiers had their dinner at 1 o'clock. The meal was followed by a general parade, dismounted drill and sword, lance or carbine exercises. The second half of the afternoon was taken up with fencing exercises or soldiers' school, where they were taught

10th Hussars drawing fodder, *c.* 1880. (AMM)

reading, writing and basic mathematics, essential for the certificates of education needed for promotion. Tea was at 5 o'clock, then there were more stable duties until 6.30, when the soldiers (except for the night guard) were officially off duty, although most needed to spend one to two hours in their barrack room cleaning their kit. Those with passes were allowed out of barracks but had to be back by 10 o'clock when the orderly sergeants checked that all were present, followed by 'lights out' at 10.15.

For the infantry, reveille was at 5 o'clock when the men would dress, make up their beds and sweep out their barrack room, ready for roll call at 5.45. After this came fatigues, a word covering a range of activities, until breakfast at 7.45. After breakfast was a parade in full drill order, followed by an hour's drill conducted by the sergeant-major, with the commanding officer's parade at 11 o'clock. Dinner was at 12.45, followed by a further hour's training. Then there was either school, physical training or sport until tea at 4 o'clock, with a final parade from 5 to 6 o'clock, after which the men were dismissed until 'last post' and 'lights out'.

Writing in 1857, Mrs Young, an officer's wife, was amazed by the tremendous activity in the camp. In the morning

the noise and bustle of camp life follow at once upon the deep stillness of the hours of rest. Aldershot is fully roused; it does not turn and stretch and yawn itself, as it were, into full consciousness of life, but is at once wide-awake - full of vigour and activity: and

then begins, as if they would never end, drills, and parades, and bands, and marchings out and marchings in, till the ear is stunned by noise, the eye confused by tunics, and the judgement, suffering a sort of moral atrophy, is so blinded, as to consider that all true greatness must inevitably commence and end with the goose step.

From Easter until the autumn, the daily routine would be enlivened by various exercises, manoeuvres and reviews on the training grounds. The largest exercises were in September, after the harvest, but there were also Easter manoeuvres, which usually included some militia and volunteers, and similar joint exercises in August. These events would begin with periods of drill and military instruction, leading up to the main event, a 'sham fight', involving opposing attacking and defending forces. Finally there would be a formal march past in review before the senior general.

Although Aldershot was quickly established as Britain's largest and most important army camp, the few 'permanent' barracks constructed in the later 1850s were the only brick-built accommodation for the next thirty years. The remainder of the camp's 'temporary' barracks continued well past their planned life, and was described by General Sir Evelyn Wood as 'wretched accommodation provided for the troops, neither wind nor rain proof'. Wood, as General Officer Commanding (GOC) from 1889, knew that the ageing wooden huts had to be replaced by new barracks, and he petitioned the War Office for money to realise his ambitious plans. In 1890, the Barracks Act was passed to fund improved army accommodation nationwide, with the largest portion of money – £1.475 million – being allocated for new barracks at Aldershot.

The 102nd Fusiliers on manoeuvres near Aldershot, 1870. (BDR)

Between 1890 and 1895 the wooden huts were demolished and replaced by new barracks, which not only provided better living accommodation but also included improved facilities for the soldiers when off-duty, with large canteens and soldiers' recreation rooms. Accommodation for married soldiers was much improved, new schools and hospitals built, while the increased emphasis on physical fitness was reflected in the construction of a large gymnasium.

General Wood thought that the new barracks should be given suitable names, rather than the anonymous letters of the old camp. In North Camp the barracks became collectively known as Marlborough Lines with individual barracks named after the Duke's great victories. In South Camp, the original permanent infantry barracks became Wellington Lines with individual barracks similarly named after his triumphs. The new barracks across the centre of the camp became Stanhope Lines, in honour of Edward Stanhope, the Secretary of State for War who had guided the Barracks Act through Parliament. Here the infantry barracks were named after British victories in the Napoleonic Wars at which someone other than Wellington had been in command, while others designed for specific corps, such as the Royal Engineers, Army Service Corps and Royal Army Medical Corps, were given names reflecting the individual corps' battle honours or notable individuals. The cavalry barracks were not named until 1909, when they became Warburg, Willems and Beaumont Barracks, after famous cavalry victories in the French Revolutionary and Seven Years' Wars.

The period between the two world wars saw further expansion, with the building of Parsons Barracks (c. 1926) for the Royal Army Ordnance Corps, Mons Barracks (1928) for the newly formed Royal Signals, Clayton Barracks (1929) as additional accommodation

Grenadier Guards drilling in Blenheim Barracks, c. 1906.

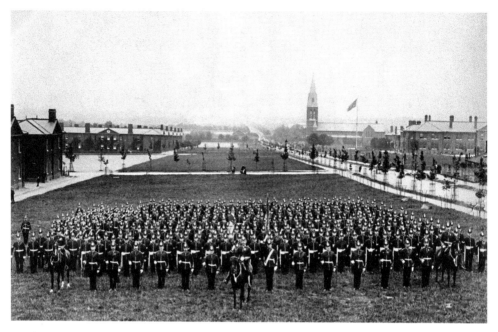

Stanhope Lines, 1899.

Clayton Barracks, typical of the interwar period.

for the Royal Army Service Corps, Hammersley Barracks (1932) for the Army Physical Training Corps and St Omer Barracks (1941) for the Army Catering Corps.

Following the Second World War, it was decided to build a new home for the Army in Aldershot, on radically different principles from the old Victorian camp. The new plan aimed to make a distinction between the soldiers' living and working areas, with married quarters built in estates on the periphery of the garrison, while the single soldiers' accommodation would be quite separate from their working areas. To achieve this it was decided that all the old Victorian buildings had to be demolished, and over the next two decades almost the whole of the old camp was swept away. Under government pressure to speed up the construction work, pre-fabricated components were used to reduce both time and cost. The first completed new building was the sergeants' mess in Lille Barracks, formally opened on 27 November 1959.

In North Camp, Hammersley, Lille, Ramilles and Tournay Barracks were rebuilt, and Blenheim Barracks became an officers' married quarters estate. Stanhope Lines were completely demolished and replaced by Montgomery Lines, named after the famous Second World War commander Field Marshal Bernard Montgomery, who opened the new complex on 7 April 1965. Wellington Lines were demolished and replaced by married soldiers' quarters. With regard to the old cavalry barracks, Willems was demolished in 1964 and replaced with two eight-storey blocks of flats for soldiers' married quarters. Warburg was demolished and the Princes Hall, Aldershot police station, magistrates' court and later the Westgate Centre were built on the site. Beaumont was demolished

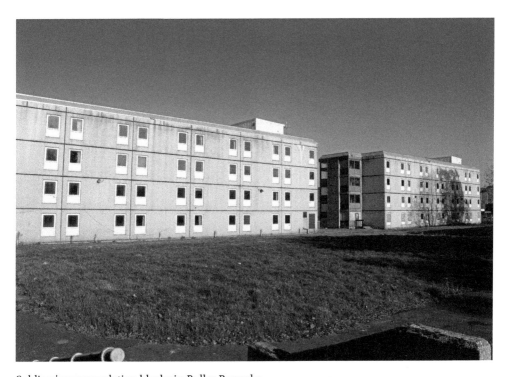

Soldiers' accommodation blocks in Buller Barracks.

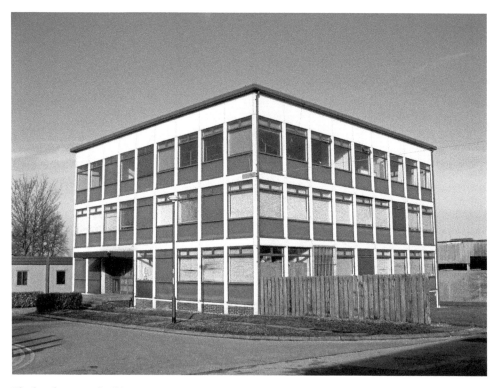

The headquarters building in Montgomery Lines.

in 1976 except for the gates, guardrooms and riding school. This became the civilian housing estate of Beaumont Park, officially opened on 3 October 1979.

In retrospect the 1960s buildings proved very much a product of their period. Although heralded at the time, as the years passed basic flaws inherent in the design and materials became obvious. They not only proved expensive to maintain but suffered from dreadful condensation and ventilation problems.

During the later decades of the twentieth century, the now discredited sixties style of flat-roofed factory-built modules was abandoned. When the old field stores, which had closed in 1968, were demolished and replaced in the 1980s with married soldiers' quarters, these were built in more traditional brick and slate. The estate was named Goose Green Park to commemorate the battle from the Falklands campaign of 1982.

By the end of the twentieth century some of the worst of the sixties accommodation was gone. The unloved tower blocks of Willems were demolished in 1992, and the Tesco superstore now occupies the site. Although Salamanca and Talavera Parks continued as married quarters estates, they were rebuilt in the 1990s with traditional houses.

There was also significant investment in the garrison's sporting facilities, including a new swimming pool, rugby stadium, tennis centre and hockey pitches, which have made Aldershot the Army's 'centre for sporting excellence'.

Although by the turn of the millennium most of the family quarters had been rebuilt, single soldiers were still living in the 1960s concrete barracks and another major overhaul

New married quarters in Talavera Park.

was needed to bring them up to a standard appropriate for the modern army. Construction of new barracks began in 2006 under 'Project Allenby Connaught', named after the First World War leader General Edmund Allenby and General HRH the Duke of Connaught, GOC Aldershot 1893–98. Although the number of military personnel was unchanged at just under 5,000, the area occupied by the Army was reduced and concentrated north of Alison's Road. To help fund Allenby Connaught, the remainder of South Camp was given over to civilian development.

The first new building to be completed was called Wellington House, built in St Omer Barracks. This contained the Garrison Headquarters and Army Education Centre, and it was taken over in December 2007. Between 2007 and 2009 all of St Omer Barracks was demolished and new soldiers' accommodation built, along with a 'super-diner' and other buildings. The military transport barracks (Gale and Travers) were largely rebuilt with more modern facilities, and there was other major redevelopment in North Camp. The construction phase of Project Allenby Connaught ended in 2014, when Montgomery House, the prestigious new headquarters building for the Army's Regional Command, was completed, although the maintenance and services contract continues until 2041. The cost of this reconstruction of Aldershot garrison totalled around £405 million.

The area of land in South Camp given over to civilian housing was 148 hectares. Grainger plc was appointed as lead contractor and they named their development 'Wellesley', the family name of the Duke of Wellington (although somewhat

New accommodation blocks in North Camp.

The 'super diner' in St Omer Barracks.

incongruously, as the original Wellington Lines were further to the south). The first new homes were built on the site of the old Maida Barracks, and the first occupants took up residence in 2016. In 2015 nearby Montgomery Lines was demolished, work began on clearing Clayton Barracks, and contractors began the huge task of converting the former Cambridge Hospital to residential apartments. When completed in around 2025, Wellesley will comprise some 3,800 new homes, along with schools, community and commercial buildings.

Aldershot Garrison continues to develop, with construction beginning in March 2017 of new accommodation for soldiers returning from Germany. The Wellesley development, on land from the old South Camp, is bringing more civilian families to the area. As it has been for over 160 years, this great camp remains at the heart of Aldershot.

Civilian houses of the Wellesley development, on the site of Maida Barracks.

2. Aldershot and Queen Victoria's Wars

Aldershot Camp was born during a time of war, for even as it was being built Britain was fighting Russia in the Crimea. The urgent need for army accommodation led to the decision to build the 'temporary barracks' in 1855, but when the Crimean War ended in 1856 not all the huts were finished and building of the permanent barracks had only just started. As large numbers of troops returned, the camp at Aldershot was soon overflowing. While in February 1856 there were 14,592 troops in Aldershot, by August the number had grown to 29,444. Before sufficient huts were available some units had to be temporarily accommodated in tents, but fortunately their time under canvas was brief as army numbers returned to peacetime levels and the remainder of the huts were completed.

The Crimean veterans were honoured by Queen Victoria, who held a number of royal reviews to express the nation's appreciation of the men's service. A grand field day on 8 July 1856 took place in the pouring rain, although, as a contemporary account noted,

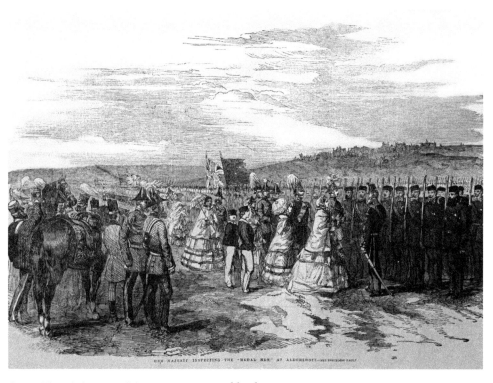

Queen Victoria inspects Crimean veterans at Aldershot.

'it was a small matter to [the soldiers] after the hardships of the Crimea'. Sometimes the Queen showed a more personal touch. The history of the Royal Sapper and Miners records that on 18 July the Queen was driving through the camp and asked for some of the Crimean veterans to be brought before her, and she spoke individually to each man.

Among the trophies brought back from the Crimea were two large bells, taken from the Church of the Twelve Apostles in Sebastopol. The Queen ordered one of the bells to be taken to Windsor Castle, and the other was brought to Aldershot, where it was hung in a wooden canopy near the top of present-day Gun Hill. When the Cambridge Hospital was built the bell was relocated to its clock tower, but fell silent when the First World War broke out. In 1961, it was taken down and placed outside Aldershot Garrison Headquarters. As the headquarters has moved over the years the Sebastopol Bell has travelled with it, until today it stands outside Wellington House, a reminder of the camp's Crimean War origins.

In 1879, Lord Chelmsford led a British invasion of Zululand. As Brigadier-General Thesiger, Chelmsford had commanded the 1st Infantry Brigade in Aldershot from January 1877 to February 1878. He suffered a terrible defeat at Isandhlwana (22 January 1879), which shocked Britain, and Aldershot units prepared for deployment to the war.

The first soldiers to leave were sixty-five men of the 16th Lancers, who departed on Monday 17 February in heavy sleet and snow. Over the next few days the 91st Highlanders, 94th Regiment of Foot, 1st King's Dragoon Guards, a Royal Artillery battery,

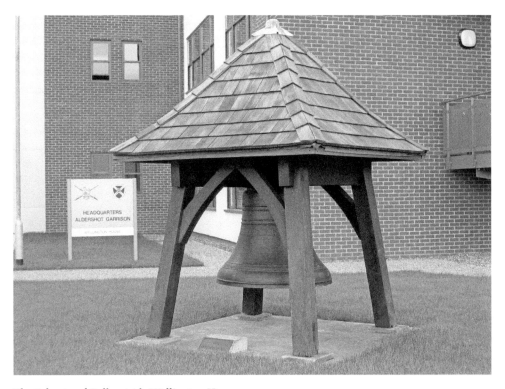

The Sebastopol Bell outside Wellington House.

and companies of Royal Engineers and Army Service Corps all left by rail, cheered on their way by crowds who lined the roads from the barracks to the railway station.

One of the most emotional departures was a draft of reinforcements for the 24th Regiment, replacements for men lost at Isandhlwana. They paraded on the morning of Saturday 1 March when Major-General Cameron congratulated them on coming forward and urged them to make every bullet 'sure to tell with direful effect on their savage foes'. Accompanied by the bands of the 41st and 75th Regiments, and amid more cheering crowds, the draft marched to Aldershot station, where they were given a patriotic farewell address by dignitaries from the Local Board of Health (the predecessors of the borough council), before leaving by special train.

Troops returning from the war received welcomes as enthusiastic as the departures. Men of the Army Service Corps, who arrived back in Aldershot by train on 19 March 1880, were met at the station by the band of the 19th Regiment, who played them back to their barracks, cheered by crowds lining the route. That evening the men were treated to what was described as 'a bountiful repast which had been provided for them by the corps out of the canteen fund'.

Probably the most famous action of the war was the heroic defence of Rorke's Drift, made famous by the film *Zulu*. Two survivors of Rorke's Drift, Sergeant Edward

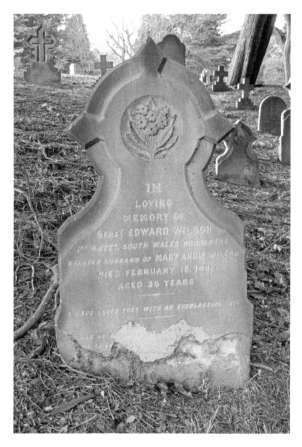

The grave of Sergeant Edward Wilson.

The grave of Corporal Daniel Sheehan.

Wilson and Corporal Daniel Sheehan, were later buried in Aldershot Military Cemetery. Sergeant Wilson had served with the 1st Battalion 24th Foot since 1874 and stayed with the regiment until discharged from the Army in 1890. He died on 19 February 1891, aged thirty-five. Daniel Sheehan, an Irishman from Cork, is often shown in the rolls of Rorke's Drift defenders as James Graham, a pseudonym he used when he enlisted in the 90th Foot (Scottish Rifles) in 1876, having previously served in the 6th Foot. How Sheehan (Graham) came to be at Rorke's Drift is a mystery, but his presence was confirmed by Lieutenant Chard and Colour-Sergeant Bourne. Sheehan was discharged in 1891 and died on 23 February 1899, aged forty-five.

The defeat of the Zulus did not end conflict in southern Africa, for in 1880 the Boers in the Transvaal rose up against British rule, initiating the First Boer War. On 28 January 1881, the British attacked Boer positions at Laing's Nek, a long steep ridge that protected the road to the Transvaal. Colonel Bonar Millett Deane led a frontal assault on the ridge, which was repulsed with heavy casualties. Deane, who had never been in action before, was killed leading the attack, and his death was regarded as epitomising Victorian values of courage. A memorial was placed outside the front of the Aldershot Garrison Church of All Saints, inscribed 'erected by his brother officers and friends in remembrance of a good and brave officer'.

The memorial to Colonel Deane outside the Royal Garrison Church.

Units from Aldershot were quickly sent out to South Africa, but as peace terms were agreed in mid-March 1881 it is unlikely that any of them would have seen any fighting.

Attention now switched to North Africa, where a revolt in Egypt against foreign control broke out in 1882, and in the following year the Mahdi began his revolt in the Sudan. Following what was now a familiar pattern, in July and August 1882 many Aldershot units left for Egypt, including two regiments of cavalry, three battalions of infantry, two batteries of artillery, a company of Royal Engineers and detachments from the support services. Most of these marched with bands to Aldershot or Farnborough stations, sent on their way by cheering crowds. An exception was the Highland Light Infantry, who paraded at 5 a.m. on 8 August, but 'owing to the early hour there were comparatively few witnesses of its departure'.

The campaign in the Sudan is mainly remembered for the siege of Khartoum (March 1884–January 1885) held by General Charles Gordon. A relief force under General Wolseley failed to reach Khartoum before it was stormed and Gordon killed. He is remembered in Aldershot by the Gordon Oak, a tree which Gordon brought back from Jerusalem in 1883 and was planted in the camp to symbolise 'endurance, strength and triumph in the Home of the British Army'.

One of the most unusual units to assemble in Aldershot was the Camel Corps for Wolseley's expedition. On 16 September 1884, Wolseley called for 1,100 volunteers from the Cavalry and Household Brigades. The three cavalry regiments stationed in Aldershot, the 2nd Dragoon Guards, 7th and 20th Hussars, were asked for fifty men each, and the local

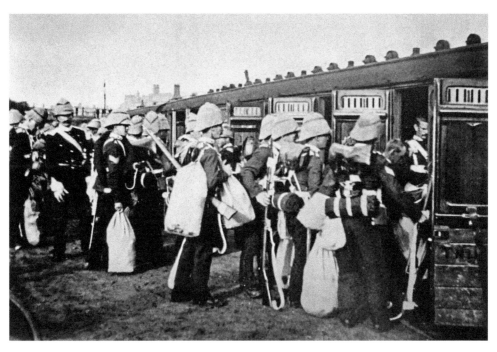

Troops leaving Aldershot by train for overseas service. (AMM)

The Gordon Oak on Hospital Road.

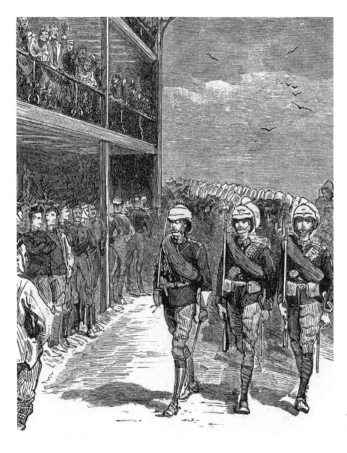

The Camel Corps marching through Aldershot Camp.

newspaper reported that 'twice as many volunteers ... stepped forward as were required'. All the volunteers assembled without horses, as they would be mounted on camels once they reached Egypt. The corps, forty-four officers and 819 Non-Commissioned Officers (NCOs) and men left Aldershot on the morning of 26 September.

In southern Africa the Second Boer War erupted in 1899. The first unit to leave Aldershot for the campaign was the 1st Battalion Northumberland Fusiliers on 23 September 1899. This left by train from the Government Sidings, originally built to bring goods into the huge field stores, where in the 1890s the Army had added a passenger platform so units could entrain within the camp.

The Northumberland Fusiliers were only the first of many battalions and regiments that went to the war from Aldershot. As one unit left, another immediately took its place, until that deployed in turn. Over the course of the war 100,000 troops passed through Aldershot for active service, comprising forty-three infantry battalions; twenty batteries of artillery; ten regular cavalry regiments; 23,000 Imperial Yeomanry and many units from the support services. The last unit to leave was a draft from the Provisional Regiment of Hussars, who embarked for South Africa the day before peace was declared.

The Boer War was a difficult campaign, which not only had a profound effect on the British Army's tactics, doctrine and training but also had a significant impact

on Aldershot. For the first time, the 1st and 2nd Infantry Divisions became standing formations in Aldershot. To house a third division, new camps were built at nearby Deepcut, Blackdown, Ewshot, Bordon and Longmoor. In 1901 Aldershot became the First Army Corps, then Aldershot Command in 1907. Mobilisation stores were added to each barracks, the field stores were extended, training became more vigorous and realistic, and each division's readiness was tested in annual mobilisation exercises. All these improvements would show their value when Aldershot next deployed for war, for the unprecedented magnitude of the First World War.

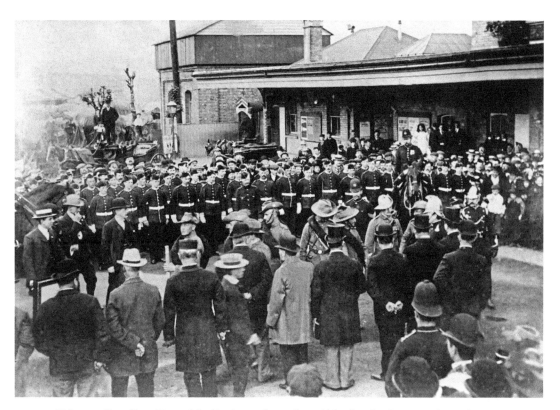

1st Volunteer Battalion, Hampshire Regiment, leave from Aldershot Station, 1901. (AMM)

3. Aldershot and the World Wars

First World War

On the afternoon of 4 August 1914, Lieutenant-General Sir Douglas Haig, GOC at Aldershot since 1912, was in his official residence of Government House. At 5.30 p.m. he received a telegram containing one word 'Mobilise' and signed 'Troopers', the code name for the Secretary of State for War. Haig passed on the message to his Command Headquarters, who in turn notified their subordinate units. At midnight the duty officer in the headquarters telephoned Haig to say that the War Office had just wired 'War has broken out with Germany'. Haig wrote that the 'orders were put in force and methodically acted upon without friction and without flurry. Everything had been so well thought out and foreseen that I, as 'C-in-C Aldershot', was never called upon for a decision.'

The mobilisation signal of three black balls was hoisted to the top of the flagpole outside the Command HQ. With its two infantry divisions, a cavalry brigade, twelve batteries of artillery and large contingents of Royal Engineers, Army Service Corps and medical units, Aldershot was the only standing headquarters that was of corps size. Because of this,

The mobilisation signal outside the Command Headquarters, 5 August 1914.

the mobilisation plans gave Aldershot Command top priority for rapid deployment. The Command formed the 1st Corps of the British Expeditionary Force (BEF), and its GOC, Douglas Haig, became the 1st Corps commander.

Reservists, called back to join parent units, flooded into Aldershot. Hundreds of men arrived every day and were put through courses of drill, weapons training and, for the cavalry, riding. Each man, regular or reserve, was medically examined and issued with clothing, equipment, weapons, 100 rounds of ammunition, identity disc, a first aid field dressing, jack knife and emergency rations. Property that was not needed, such as full-dress uniforms, was put into storage or returned to the Ordnance Department.

At midnight on 6 August, the 1st Battalion Scots Guards was the first unit to report that they were fully mobilised. Others followed over the next few days, and all were ready by 11 August when George V held a royal review of the command. The next day the first units left the camp. Unlike the deployments in the nineteenth century, there was no pomp and ceremony: they quietly marched out of their barracks in the early hours of the morning. Around half the infantry left on 12 August, with the remainder departing the next day, and the cavalry units moved out on the 15th. All left by special trains, some from Aldershot and Farnborough stations, and some from Government Sidings. The first destination was Southampton, from where the men were ferried to Le Havre and Boulogne in France, before moving on to Belgium to meet the enemy.

As the regulars moved out, their place was taken by a flood of recruits responding to General Kitchener's famous appeal for volunteers. So many thousands of recruits poured into Aldershot that there were shortages of accommodation, equipment and even basic uniforms. Private James Wilson of the 7th Leicestershire Regiment recalled:

> We were quickly sorted out and began training the first day we arrived ... I was only a kid but a number of men in the battalion were real tough Yorkshire miners. We had no uniforms and our civilian shoes wore out before we ever received boots, in fact the miners said they would refuse to parade again if they didn't get proper boots. After a time we were given uniforms but not khaki, there was no khaki to be had, so they gave us a red uniform with navy blue cuffs and white braiding ... we didn't get khaki until March 1915.

The numbers of troops meant that all available accommodation was soon filled. Although all barracks were ordered to increase sleeping capacity by 50 per cent by the end of August, even these measures were insufficient. The East and West End Schools were requisitioned to house some of the men, while others went into tents pitched on every available open patch of ground. New huts were being built as quickly as possible but as winter approached not enough had been finished, so from November men began to be billeted in private houses in Aldershot. Billeting was intended to be a short-term solution while army huts were constructed, but it continued for short periods throughout the war when no other accommodation could be found.

It is difficult to be certain about the exact numbers of soldiers in Aldershot during this period, as units and men were coming and going at such a rapid rate. In August 1914 there were 17,643 military personnel in Aldershot Garrison, 27,245 across the whole

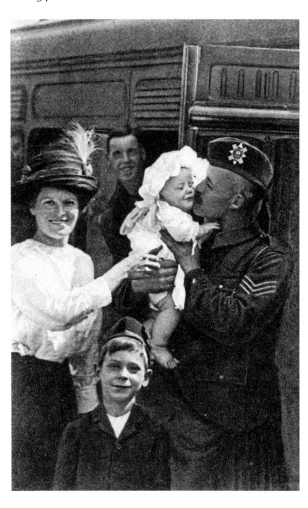

Left: The Black Watch leaving Aldershot. (PS)

Below: Recruits for the Scottish Division in Stanhope Lines, 1914. (AMM)

of Aldershot Command. After the regular units left, some of the New Army divisions were formed in Aldershot, such as the 9th (Scottish), 14th (Light) and 15th (Scottish) Divisions. Many more of the new divisions were raised and did basic training in their local areas, before being sent to Aldershot for final intensive war training and deployment overseas. Out of thirty-one infantry divisions raised for the New Armies, sixteen were assembled or trained in Aldershot Command. Peak activity came in September 1915 when seven divisions, around 126,000 men, were training in the Aldershot Command area. From the beginning of 1916 this number fell sharply as the newly trained formations were sent to the front. The first major test for the New Armies was the Battle of the Somme (1 July–18 November 1916), and half of the New Army Divisions who fought in the battle, thirteen out of the total of twenty-six, had been raised or trained in Aldershot Command.

As well as sending men to fight, Aldershot was of crucial importance in treating the casualties. Late at night on 30 August 1914 the first hospital train arrived at the Government Sidings, bringing around 200 wounded men from the Battle of Mons. The soldiers were transferred to the great Aldershot military hospitals, the Cambridge and the Connaught. Aldershot was the first place in Britain to take wounded troops from the Western Front, and a great many more would follow over the course of the war. At the Connaught Hospital in North Camp, in addition to the physical wounds, men suffering from shell shock and other mental conditions were treated.

The Cambridge Military Hospital in South Camp became the first British Military Hospital to have a dedicated Plastic Surgery Unit, created by the outstanding surgeon Harold Gillies. Born in New Zealand, Gillies studied medicine at the University of

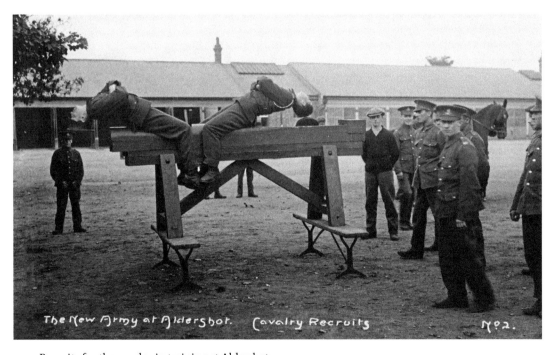

Recruits for the cavalry in training at Aldershot.

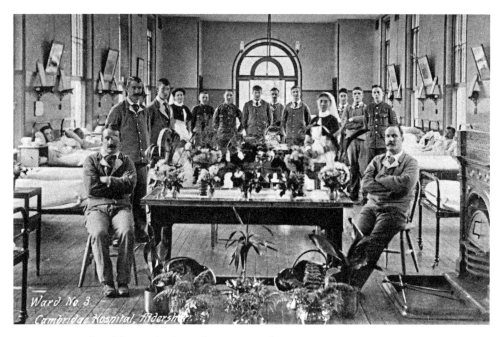

Patients in Ward 3 of the Cambridge Military Hospital.

Cambridge and worked at St Bartholomew's Hospital. On the outbreak of war, Gillies joined the British Red Cross and in France saw the work of pioneering surgeons Claude Auguste Valadier and Hippolyte Morestin, becoming fascinated with their techniques of restorative surgery. Gillies approached the chief army surgeon, suggesting that a unit should be set up in Aldershot to treat the many men who were being admitted with hideously disfiguring wounds to their faces. The Army agreed, Gillies was made a captain in the Royal Army Medical Corps (RAMC), and the Plastic Surgery Unit was opened at the Cambridge Military Hospital in January 1916. There Gillies was joined by Captain William Kelsey-Fry, a dental surgeon, and the pair worked together on reconstructing the faces and jaws of wounded soldiers.

With the start of the Battle of the Somme, Gillies was allocated an extra 200 beds, but it soon became clear that there was a need for even more space. Subsequently the unit moved to the Queen's Hospital in Sidcup, where the work continued until the end of the war. Between the units at Aldershot and Sidcup, Harold Gillies and William Kelsey-Fry reconstructed the faces of 11,572 patients. Gillies was knighted in 1930.

Citizens of Aldershot served in all services and theatres of war. In fact the naval battle of Jutland (31 May 1916), where six local sailors were killed in action, cost as many Aldershot lives as the first day of the Battle of the Somme.

The local infantry battalion was the 1st/4th Battalion of the Hampshire Regiment, sometimes nicknamed 'Aldershot's Own' because of the number of the town's residents in its ranks. In October 1914, the 1st/4th Hampshires departed for India, from where they were deployed to Mesopotamia (modern-day Iraq) in March 1915 to fight against the Ottoman Turks. By the end of July a combination of casualties from fighting and sickness

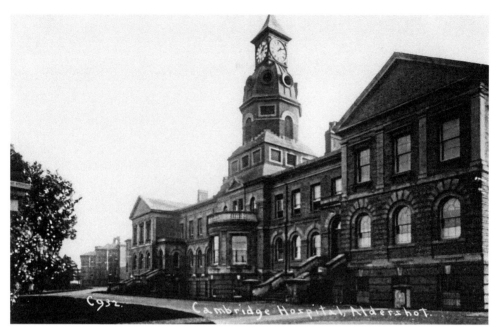

The Cambridge Military Hospital, where Gillies pioneered plastic surgery.

caused by the extreme conditions had reduced the battalion from an initial strength of around 800 to less than 150 men.

After being reinforced, the battalion was ordered to Kut al Amara, where the British forces were gathering after a failed advance on Baghdad. The 1st/4th HQ staff and 'A' Company were in Kut when it was besieged by the Turks, while the remaining companies joined the forces attempting to relieve the siege. On 29 April 1916, the British forces in Kut surrendered after suffering terrible conditions, among them ten officers and 157 other ranks from the 1st/4th Hampshires. In captivity they were maltreated and underfed, and those who survived were put to work on the Constantinople to Baghdad railway. All ten officers of the 1st/4th survived to be repatriated after the war, but less than fifty of the NCOs and privates survived.

The remainder of the 1st/4th Hampshires fought a number of engagements throughout the rest of 1916 and into 1917, and the 1st/4th entered Baghdad on 13 March 1917. In 1918 elements of the 1st/4th were sent to the Caucasus, where they were involved in the occupation of Baku, protection of the Trans-Caspian railway, and repulsing Russian Bolshevik attacks.

On the morning of 11 November 1918, rumours swept through Aldershot town that a ceasefire had been signed. Crowds gathered in the town centre, while large numbers of troops congregated outside the Army Headquarters. At 11.00 the camp sirens were sounded to indicate that the ceasefire had come into effect, and the GOC, Sir Archibald Murray, appeared on the balcony of the HQ but few heard his speech for the cheering. A military band then led the soldiers around the parade ground, singing popular songs as they went. Work came to a halt for the day, and the schools were given a half day holiday.

1st/4th Hampshire Regiment survivors of the siege of Kut in Winchester, 1919. (RHR)

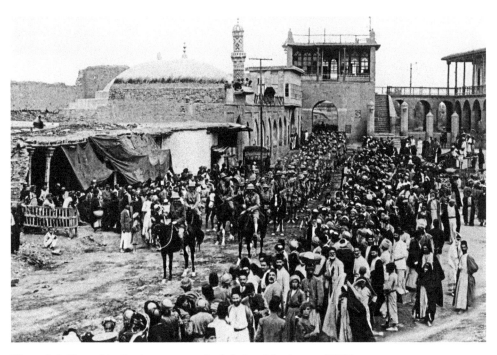

The 1st/4th Hampshire Regiment enters Baghdad, 13 March 1917. (RHR)

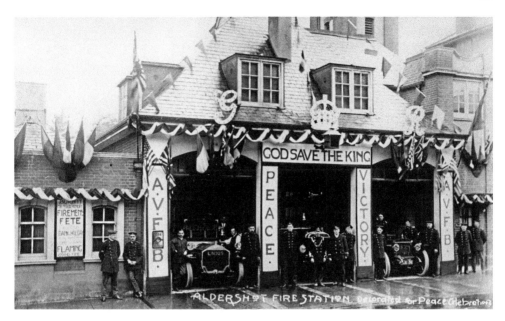

Aldershot Fire Station decorated to celebrate peace, 1918.

By 2.00 p.m. the town centre was thronged with people singing, dancing and waving flags. The Wellington Works siren sounded for ten minutes along with church bells, the railway fog signal and railway engine whistles, a cacophony of noise not heard for many years. A Service of Thanksgiving was quickly arranged in the Municipal Gardens in the afternoon. At night fireworks were set off, while the camp loosed off star shells and signals rockets. It was described as 'the most delirious outburst of happiness ever, the most amazing scenes that Aldershot has ever witnessed'.

The joy and relief that the war was over was tempered by grief and mourning for the appalling numbers of casualties. From Aldershot, Farnborough and Cove (the present Borough of Rushmoor), 671 residents were killed, and many more injured. After four years of industrialised warfare, many hoped that this would be 'the war to end all wars'. But it was not to be, and a mere twenty-one years after the scenes of rejoicing for peace, the Aldershot Divisions would once again be mobilising for war in Europe.

Second World War

After the First World War the traditional horsed cavalry and horse-drawn artillery and transport were clearly outdated, and conversion to a fully mechanised army began. Owing to the recession of the 1920s, the changes could only be brought in over a remarkably long period and the first Aldershot cavalry unit to be mechanised was the 1st Dragoons in 1926. With mechanisation came inevitable changes to the barracks – when the 11th Hussars in Willems Barracks were mechanised the old Riding School became garages, the remount stables housed Morris trucks, and a petrol pump was installed at the guardroom. The last fully horsed cavalry regiment to be stationed in Aldershot was the Royal Scots Greys, who took their horses with them when they left in October 1937.

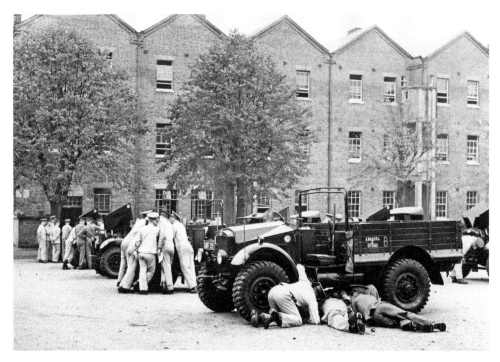

Vehicles of the King's Royal Rifle Corps, Salamanca Barracks, 1938.

Their replacement regiment was the King's Dragoon Guards, who, scheduled for mechanisation, left their horses in India.

In 1938, the 1st Cavalry Brigade was due to leave Aldershot and join a new Armoured Division at Tidworth on Salisbury Plain. However, owing to the lack of suitable accommodation in Tidworth, three cavalry regiments remained in Aldershot during 1939, the King's Dragoon Guards, 4th/7th Dragoon Guards and 12th Lancers.

In nearby Farnborough, in 1921, a battalion of the Tank Corps (later the Royal Tank Regiment) had moved into Pinehurst Barracks, originally built for the Royal Flying Corps. The barracks were renamed Elles Barracks, after Sir Hugh Elles, GOC Tank Army (1918–19), and were extended in the 1930s to take a second tank battalion.

War was declared against Nazi Germany on 3 September 1939. At this time Aldershot Command, with 24,426 personnel including the resident 1st and 2nd Divisions, was still the most important concentration of military personnel in the country. Aldershot mobilised immediately, the 1st Army Corps was reconstituted as the spearhead of the British Expeditionary Forces with the GOC Aldershot, Lieutenant-General Sir John Dill, as Corps Commander. Within three weeks Aldershot's resident divisions had deployed to France.

Neither of the old resident divisions would return to Aldershot. Both fought with 1st Army Corps in France in 1940, were driven back and evacuated through Dunkirk. In 1942 the 1st Division was sent to North Africa, then fought through Italy until it was sent to Palestine in January 1945. After Dunkirk the 2nd Division was deployed to India, fought

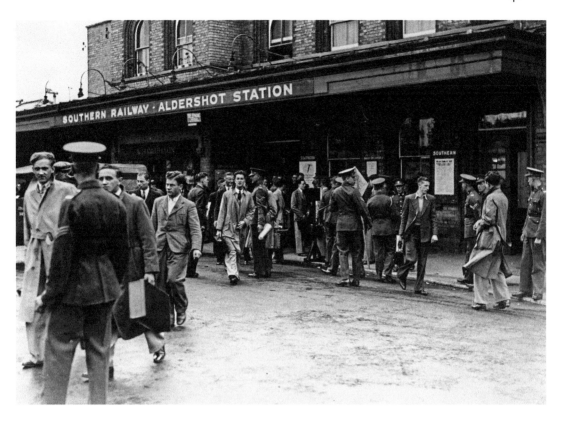

Above: Reservists arriving at Aldershot Station following the declaration of war, 1939. (AMM)

Right: Canadian soldiers march into camp after arriving at Government Sidings, 1940. (AMM)

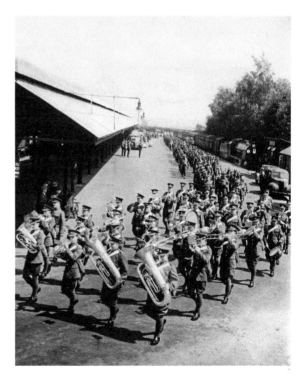

at the battles of Imphal and Kohima (March–July 1944), then advanced into Burma and were part of the force that took Mandalay in March 1945.

After the 1st Corps left in 1939, in their place came the first wave of Canadian Army troops to enter the Second World War. After Canada declared war on Germany on 10 September 1939, thousands of volunteers came forward to enlist. The Canadian First Infantry Division, a mixture of 22,000 regulars and new recruits, came to Aldershot between December 1939 and January 1940 during one of the coldest winters on record. One Canadian artilleryman remembered the hardships they faced:

> Eventually we made it to Lille Barracks in Aldershot. We had no real equipment with us, only one set of battle dress, one pair of boots, and cavalry cloaks from World War One! However, after 6 months of intensive training we looked and acted like soldiers.
>
> Life in barracks was very unpleasant. There was a small fireplace in each of the rooms, which could only hold about 6 coals. The weather was raw and cold, and there was no way of keeping dry. British rations were not the best ... The boys had a saying that we dined well since you could have a choice of lamb, ram, sheep or mutton.

Commanding the Canadians was Major-General A. G. L. McNaughton, who demanded the highest standards and insisted on hard and realistic training. In summer 1940 the First Canadian Infantry Division moved out of Aldershot bound for the south coast, to be followed into the camp by the recently arrived Second Canadian Division. As the Canadians increased in strength they formed the First Canadian Corps and McNaughton set up a new headquarters at Headley Court in Surrey, later reconstituted as HQ First Canadian Army. Even so, throughout the war Aldershot remained the main base for reinforcements coming from Canada, and between 1939 and 1946 some 320,000 Canadians passed through the camp.

Although the most numerous, the Canadians were not the only overseas troops in Aldershot, which at various times hosted units from Australia, New Zealand and South Africa, along with soldiers from occupied European countries including Poles, Free French, and the Royal Netherlands Army. The people of Aldershot welcomed their visitors, who in turn tried to bring some cheer to the town, which was under wartime regulations of rationing, blackouts and shortages. The Canadians were particularly generous to the local children at Christmas time when they organised parties with appearances by 'Santa', presents, sweets and ice creams.

Following the withdrawal from Dunkirk there was a real expectation of imminent German invasion. Aldershot was on the 'GHQ stop line', designed to delay any German invasion advancing on London from the south. The Basingstoke Canal was a natural obstacle, and between June 1940 and March 1941 it was reinforced by a chain of pillboxes from which defending forces could lay down heavy fire on enemy forces attempting a crossing.

The Local Defence Volunteers (LDV) were raised in May 1940 for home defence. The Aldershot Volunteers became No. 9 Platoon of the Rotherwick Company LDV. When the LDV became the Home Guard, the Aldershot unit became No. 6 (Aldershot) Company, 25th (Rotherwick) Battalion, Hampshire Home Guard, with the Company's headquarters at Elm Place in Church Lane East. By late 1942 the strength of the Aldershot Company had reached 500 volunteers.

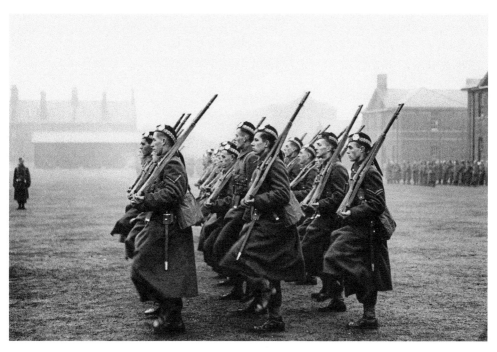

The Toronto Scottish in Stanhope Lines, *c.* 1940. (AMM)

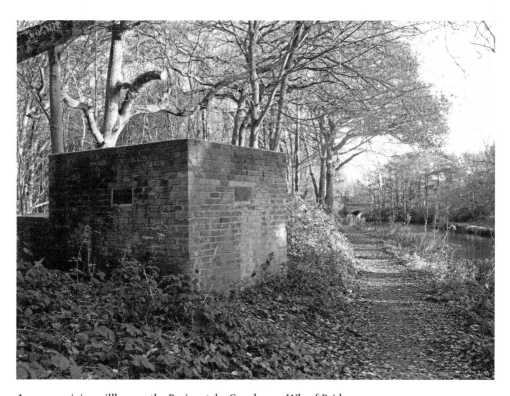

A rare surviving pillbox on the Basingstoke Canal, near Wharf Bridge.

Part of Aldershot's Home Guard – 6 Platoon 'A' Company in 1944. (AMM)

In 1941 Lieutenant-General Montgomery, as GOC South Eastern Command, ordered that a defensive perimeter should be established around the key areas of Aldershot Camp, with a ditch and anti-tank defences. The GOC Aldershot reported that:

> The garrison available for this defended locality is about 5000 - 6000 rifles. The actual number varies considerably from day to day. The personnel will be found from Training Units and Static Units located within the perimeter, from reinforcements for field units awaiting posting and details of field force units left in Aldershot when the formations they belong to move out.

He also noted a lack of any heavy weapons, proper equipment or engineering personnel. Although some preliminary work was done, the defence works were never completed, and by the end of 1942 it was agreed by Army HQ that no further work need be done owing to the changed circumstances of the war.

Although the land defences were never tested, Aldershot did suffer some attacks from the air. In anticipation of air raids, the Air Raid Precautions (ARP) organisation had been formed at the start of the war, and by 1941 the local paper reported that it was adequately equipped but 'not quite adequately staffed in all departments'. Regular training exercises were held, typical of which was a 'blitzed street' exercise in November 1942. Voluntary fire-watching groups were formed in 1940, but even after the government had introduced

Anti-tank defences by North Camp station in the early 1980s. (BB)

compulsory enrolment, the number available at the end of 1941 was still only half those required. Registration was extended to include women, who significantly augmented the fire-fighting strength of the borough.

The first bombs fell on 6 July 1940, which Lieutenant-Colonel Kenneth Bradford, of British Columbia, recalled as 'a miserable day, the only memorable part was the steady, cold drizzle'. A single German aircraft flew over and dropped three bombs onto Canadian soldiers who were working on their vehicles on the parade ground of Salamanca Barracks:

The first fell harmlessly into a tank park across the road from us, the second just missed the final lorry making a two inch crater in the paving of the square (and just missing the window where I was standing), the final one missed the window on the other wall demolishing a telephone kiosk beneath it. The tragedy was that this ineffective and amateurish early air raid ... had absolutely no material effect on our equipments [but] the enemy blunder did end in real tragedy, three fatalities.

The three Canadians who died, QMS Knox, Staff Sergeant Bailey and Private Sword, of the Royal Canadian Ordnance Corps, were the first Canadian soldiers to die on service overseas from enemy action, and a further twenty-nine men were injured. In 1969, the Royal Canadian Legion of Toronto presented a memorial plaque for the men who died, which was mounted on the old Aldershot Command Headquarters building. The plaque was moved to the new HQ, Montgomery House in North Camp, and rededicated when the building was opened in 2014.

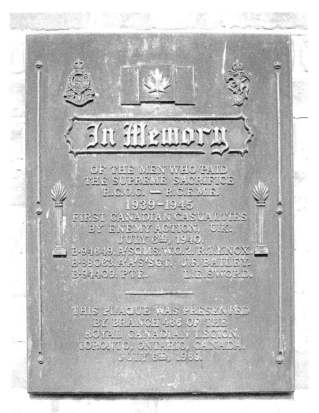

Left: Memorial plaque to the Canadians who died in enemy bombing in 1940.

Below: Bomb damage at the REME workshops. (AMM)

Remarkably, Aldershot suffered no systematic bombing during the war, a common belief being that the German Army wanted to keep it intact for its use after the invasion of Britain. After the war the town clerk, Llewellyn Griffiths, wrote that 'forty bombs actually fell in Aldershot or on the Aldershot barracks'. Fortunately, casualties were very low. In addition to the three Canadian soldiers killed in the raid of July 1940, a civilian NAAFI manager died, and in October 1940 two young men were killed by a bomb in Farnborough Road. In other raids, a bomb caused serious damage to a Royal Electrical and Mechanical Engineers' workshop under construction, a stick of bombs fell in Queen's Avenue near the Army School of Physical Training and an incendiary bomb hit the Hammersley Barracks cookhouse.

Two V-1 flying bombs landed on Aldershot, one of which landed on the Oaks School in Eggars Hill, killing one pupil and injuring many others. Ellsie Russell was a pupil in the nearby County High School, and she remembered that it damaged surrounding houses and blew in the windows at her school. 'I was in Art class and recall our teacher telling us to crouch down under our desks,' she wrote, 'fortunately no-one was hurt.' At the end of the war Griffiths reported that around 2,500 properties in Aldershot had been damaged by bombs, although loss of life had been very small.

Throughout the war years the population of Aldershot responded with enthusiasm to many fundraising activities for the war effort, such as the 'Spitfire Fund', which raised £7,418 to buy Aldershot's Spitfire, number P8136. 'War Weapons Week' in January 1941

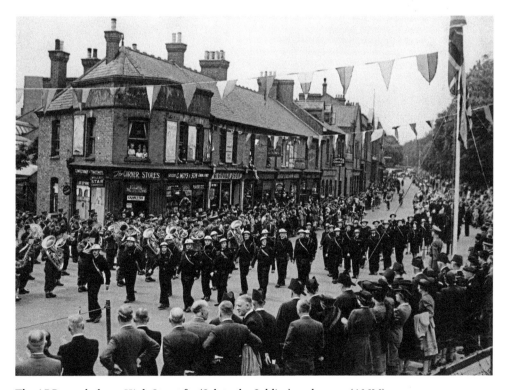

The ARP march down High Street for 'Salute the Soldier' week, 1942. (AMM)

The 'Wings for Victory' parade in Wellington Street, 1944.

amassed a remarkable £300,868, while 'Warship Week' in February 1942 raised £193,251, enabling Aldershot to adopt its own submarine, HMS/m *Tuna*. The 'Tanks for Attack Campaign' generated £88,330 in ten weeks, which gave Aldershot the right to name three tanks, and in 1944 the 'Salute the Soldier Week' raised £262,684, enough to clothe a battalion of the Hampshire Regiment, equip a parachute battalion and a field medical unit.

During preparations for the 1944 invasion of Europe, Aldershot was a hive of activity as one of the centres for the build-up of forces. Roads got gradually busier as movements of tanks, armoured cars and trucks increased; along Queen's Avenue trucks were parked under the trees and on the grass verges, and the Queen's Parade was full of transporters, lorries and motorbikes. The parade grounds in the barracks were crammed with vehicles and equipment, and the Hog's Back was lined for 5 miles with tanks. As D-Day approached, this massive force left Aldershot for the south coast, leaving the town eerily quiet. The first intimation that the invasion was underway was when large numbers of aircraft, many from nearby RAF Hartford Bridge, flew over the town on missions in support of the land forces.

Finally, in May 1945, came victory in Europe, followed by victory in Japan in August, both occasions for widespread rejoicing in the town, celebratory parades, services of thanksgiving in the churches and many street parties for local children. The general outpouring of joy was only briefly disturbed in July, when groups of Canadian soldiers, unhappy at delays in returning home and aggrieved at what some perceived as

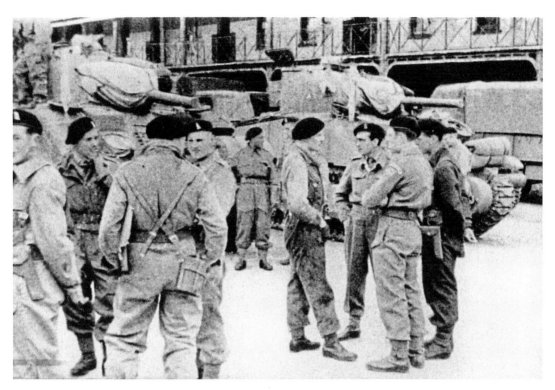

A rare photo of the D-Day preparations in the cavalry barracks. (AMM)

profiteering by local traders, rampaged through the town causing much damage to shops and businesses. The Canadian authorities, and the bulk of the Canadian soldiers, were appalled at such behaviour after the years of friendly relations with the townspeople, and swift action was taken against the perpetrators. The town knew that these were the actions of a small number of hotheads, and in a sign of their true feelings to their overseas visitors bestowed the Freedom of the Borough on the Canadian Army Overseas on 26 September 1945.

4. Aldershot and Conflicts since 1945

The Second World War was followed immediately by the Cold War, as Western capitalist countries confronted the expansionist threat of the Soviet Union. Britain also faced the problems of withdrawal from empire, attempting to maintain order against nationalist and communist insurgents as it transferred its former colonies to new independent governments. To meet these commitments, Britain introduced National Service, and thousands of young men passed through Aldershot on their National Service training.

Only five years after the end of the Second World War, Britain was involved in a major war in Korea as part of a United Nations effort to protect South Korea from being overrun by communists from North Korea supported by China. Inevitably, units from Aldershot were deployed throughout the conflict. The 5th Royal Inniskilling Dragoon Guards, who left Aldershot for Korea in October 1951, held their veterans reunion a week before their departure date, remembering past comrades at a service in the Royal Garrison Church where the Warriors Chapel forms the regiment's 1914–18 war memorial.

In July 1956, President Nasser of Egypt seized control of the Suez Canal, causing Britain and France to organise military action to reoccupy it. The British element was led by the airborne forces and, at the beginning of August, 2nd Battalion the Parachute Regiment left Aldershot for embarkation at Portsmouth. The 1st and 3rd Battalions, which had been in Cyprus since January, were quickly flown back to Aldershot for some refresher parachute training before they were also sent to Egypt.

On 5 November, 3 Para parachuted onto El Gamil airfield, the last time a battalion-sized operational parachute assault would be attempted. Despite fierce opposition they took their objective, while 2 Para landed by sea and advanced down the canal. Although they inflicted a significant defeat on the enemy, political and international pressure forced an end to the campaign.

In the 1960s men from the Parachute Regiment were back in the Middle East, this time fighting rebels in Aden. During 1 Para's deployment in 1965 the Commanding Officer was awarded the Distinguished Service Order, three officers the Military Cross, one NCO the Military Medal and ten men were mentioned in despatches. After the battalion returned to Aldershot, a service of thanksgiving was held in the Royal Garrison Church on 21 January 1968, followed by a parade down Wellington Avenue. In 1968, for the first time since the Second World War, no British soldier died on active service. Regrettably it would also be the last year, as in 1969 conflict nearer home began one of the Army's longest deployments.

What became known as 'The Troubles' began in Northern Ireland in 1969 when the Irish Republican Army (IRA) took advantage of civil rights protests to begin a violent insurgency aimed at forcing Northern Ireland into a united Irish Republic. The Army was

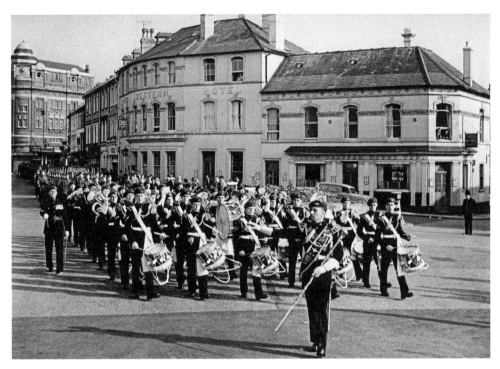

The Parachute Regiment marches to Aldershot station to deploy to Suez, 1956. (AMM)

sent to keep order and Operation Banner, as the deployments to Northern Ireland were known, would continue until 2007.

One of the most heavily engaged battalions in the early years was the 1st Battalion the Parachute Regiment, who did a twenty-month tour from September 1970 until May 1972, and was involved in the controversial 'Bloody Sunday' in Londonderry in January 1972. Brought back home in May 1972, it returned two months later, along with 2 Para, to take part in the operation to clear the 'no-go' areas that the IRA attempted to set up in Belfast and Londonderry. 1 Para stayed in the province for another four months.

The Northern Ireland troubles were brought into the heart of Aldershot on 22 February 1972, when the IRA exploded a car bomb outside the officers' mess of 16 Parachute Brigade in Montgomery Lines. The scene was described by the *Aldershot News*:

As a plume of grey-brown smoke shot up into the air, windows of shops in the High Street were shattered by the force of the blast. Within seconds, ambulances and fire tenders were at the scene. And men from nearby barracks whose windows had been blown in had already dashed to the dust-shrouded wreckage to claw at the rubble with their hands to release the trapped victims.

On the scene itself, the square mess building stood a mere skeleton - with a heap of rubble as high as the ground floor spewed out in front of it. Grey concrete dust covered everything and soon the grim-faced rescue workers took on as pale a look with the powder on their faces as the injured they dragged out from the debris.

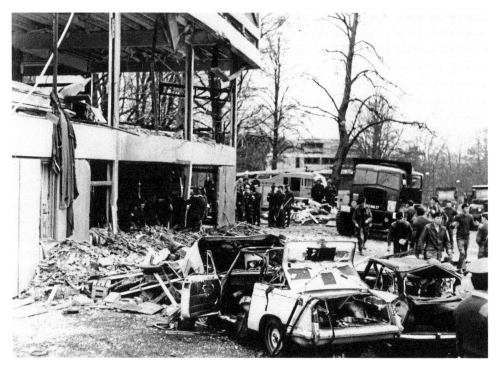

Destroyed cars and debris from the IRA bomb. (AMM)

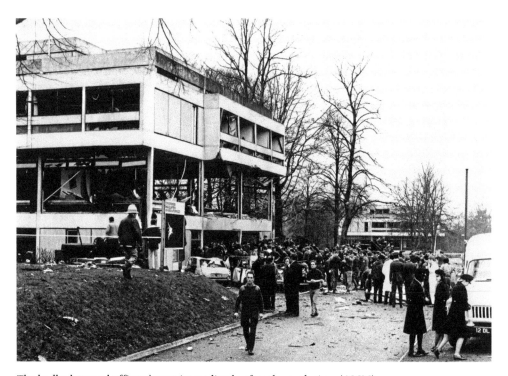

The badly damaged officers' mess immediately after the explosion. (AMM)

A statement by the IRA claimed it was a retaliation for 'Bloody Sunday', but there was revulsion throughout Britain that this cowardly act had killed seven people, none of whom had been involved in the events in Londonderry. The dead were Father Gerard Weston, a Roman Catholic Padre; Mr John Hasler, a gardener and five civilian women mess staff: Mrs Margaret Grant, aged thirty-two; Mrs Joan Lunn, thirty-nine; Miss Sheri Munton, twenty; Mrs Thelma Bosley, forty-four and Miss Jill Mansfield, thirty-four. Sixteen people were injured, including three civilians and thirteen military personnel, among whom were a private in the Women's Royal Army Corps, seven army officers, one staff sergeant and four RAF officers.

A funeral service for Father Weston was held at the Garrison Church of St Michael and St Sebastian, before the body was taken to his home town of Crosby for burial. Thelma Bosley and Margaret Grant were buried in the Aldershot Military Cemetery, Jill Mansfield in Aldershot Town Cemetery and Violet Lunn, Sheri Munton and John Haslar were cremated at Aldershot Crematorium. The ruins of the mess building were demolished and the site was turned into a memorial garden, in the centre of which was a plaque commemorating those who died.

There were no further IRA attacks on Aldershot, but soldiers from the garrison continued to serve in Northern Ireland until a political solution was found and the Good Friday Agreement of 1998 brought the worst of the violence to an end. A memorial in the Aldershot Military Cemetery remembers those soldiers of the Airborne Forces who died during Operation Banner.

One of the most unexpected modern wars occurred in 1982, when the forces of the Argentinian dictator, General Galtieri, invaded the Falkland Islands, violating

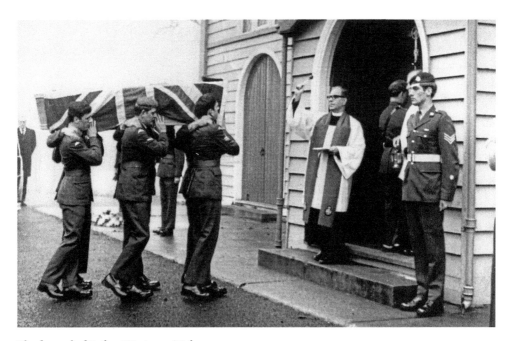

The funeral of Father Weston, 26 February 1972.

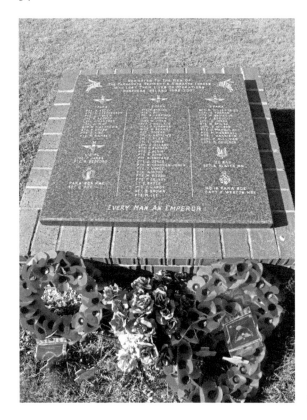

Parachute Regiment memorial to
those who died in Northern Ireland.

British sovereignty. A task force was hurriedly assembled to retake the islands, including the 2nd and 3nd Battalions of the Parachute Regiment, who left their barracks in Montgomery Lines in April 1982 for the long journey south. The Army had to fight a number of very fierce actions where they prevailed through their courage, professionalism and fighting abilities. The Argentinians surrendered in June, and the Falklands remain a British overseas territory.

A victory parade was held in Aldershot on 1 October 1982. The day began with a memorial service at the Recreation Ground attended by 600 men from the Parachute Regiment, 9 Parachute Squadron Royal Engineers, 5 Infantry Brigade HQ and Signals Squadron, 16 Field Ambulance RAMC and 10 Field Workshops REME. They were joined by Prince Charles as Colonel-in-Chief of the Parachute Regiment, and a crowd of some 7,000, who gave a standing ovation as the Paras marched into the ground. The most solemn moment came when the names of forty-four airborne soldiers who had been killed in the Falklands were read out.

Following the service the Parachute Regiment marched through the town as thousands of people lined the streets, which had been decorated with bunting and Union Jacks. Prince Charles took the salute at the Princes Hall, where the next-of-kin of men who had been killed in the Falklands were given positions of honour with the VIPs. The local newspaper reported that: 'The crowds loved every minute of it. They cheered and cheered. They waved flags and made it a day the Paras will never forget.'

2 Para march out of Montgomery Lines for the Falklands, 6 April 1982. (AMM)

Prince Charles takes the salute at the Falklands Victory Parade. (AMM)

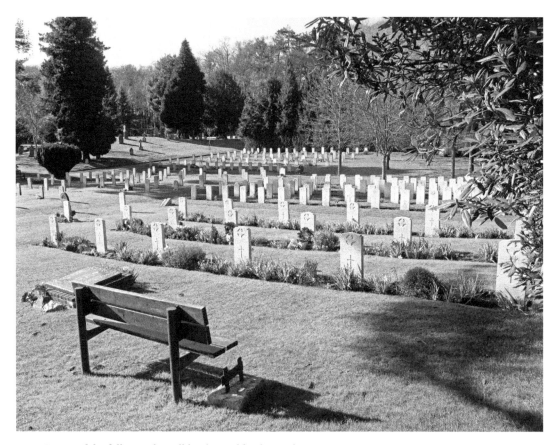

Graves of the fallen in the Falklands in Aldershot Military Cemetery.

Many of the families of the soldiers who had died elected to have the bodies brought back to Britain for burial, and a section of the Aldershot Military Cemetery was given over to the fallen from the Falklands. A national day of remembrance was declared for 14 November 1982, and in Aldershot a special service at the Royal Garrison Church was packed with mourners, among whom were many servicemen wearing their Falklands medals along with Mrs Sara Jones, the widow of Colonel 'H' Jones, who had been posthumously awarded the Victoria Cross.

The Army was next involved in a major war in 1991, when a force was sent to the Gulf to free Kuwait from the invading Iraqi forces of Saddam Hussein. Around 2,000 troops from the Aldershot area were deployed, among whom were almost the entire medical staff from the Cambridge Military Hospital.

Following the vicious civil war that followed the break-up of Yugoslavia, and the terrible atrocities committed, peacekeeping forces were sent to Bosnia in 1992 and to Kosovo in 1999. Among the soldiers who left Aldershot for Kosovo was Sarah Roe, who at age seventeen became Britain's youngest woman soldier to be sent on peacekeeping duties.

Particularly distinguished in this difficult work was 101 Logistic Brigade, which was awarded the Wilkinson Sword of Peace in recognition of their humanitarian work

7 Para Regiment, Royal Horse Artillery, in Bosnia, 1995. (AMM)

among refugees during the Kosovo crisis. At a parade in Aldershot in January 2001 the Procurement Minister, Baroness Symons, presented the sword and the soldiers were told that their efforts had prevented an even greater catastrophe.

The Sword of Peace had previously been awarded to another Aldershot formation, 5 Airborne Brigade, for its role in the United Nations' mission to Rwanda in 1994. Named in the citation were 23 Parachute Field Ambulance, 5 Airborne Logistic Squadron and 9 Parachute Squadron, Royal Engineers. Defence Secretary Michael Portillo presented the sword during the Airborne Forces Day parade in 1996.

The Paras were back in Africa in 2000, when an 800-strong battle group was sent to Sierra Leone to evacuate British nationals, Commonwealth and European citizens who were threatened by the insurgent Revolutionary United Front. The soldiers had deployed with very little equipment, and were instructed to 'Only take what you can eat, drink, shoot out of the front end of your weapon or carry on your back'. They had some sharp firefights with the rebels. 'It was the first time the platoon had rounds whizzing over their heads,' one paratrooper said. 'It took a couple of seconds to recover from that, then the years of training kicked in.' The operation was successful and, as one soldier was quoted as saying in the press, 'It beats sitting around in Aldershot'.

The Army returned to the Middle East as part of the invasion forces to remove Saddam Hussein from power in Iraq, when more than 2,500 Aldershot-based troops were sent

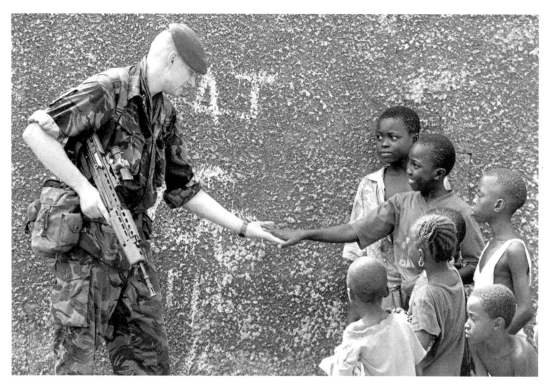

Lance-Corporal Dan Withers of 2 Para with local children in Sierra Leone. (Alamy)

to Iraq. Although Saddam Hussein's forces were rapidly defeated, the campaign in Iraq grew increasingly unpopular as it dragged on for years with continuing violence between the rival militias. Many units served repeated tours in Iraq, in what were undeniably difficult circumstances. Typical was the experience of 1 Royal Welch Fusiliers, who wrote in the *Aldershot Garrison Herald* in 2004 that life in Iraq

> is a world apart from that of their base in rainy Aldershot. Operating in daytime temperatures in excess of 40°, enduring heat of 50° when spending time in armoured vehicles, the men are facing new challenges which stretch even their exhaustive training regime. It is important to appreciate the achievements that are being made. Too often it is only the tragic and the shocking incidents that hit the headlines, with very little recognition of the achievements of the battalion in their day to day work ... The reconstruction work and training of Iraqi security services continues to bring many rewarding moments.

Although the Iraq War was highly controversial, support for the soldiers remained high, and units returning home enjoyed the traditional welcome back.

The last major conflict (at the time of writing) was the long drawn out campaign in Afghanistan, which began in 2001 after the Al Qaeda attacks in the United States, with allied US and British forces assaulting terrorist strongholds. Following this initial phase,

the British took up positions in the southern provinces of Helmand and Kandahar, with the aim of preventing the militant Islamists recovering their strength.

In Afghanistan the British soldiers showed notable courage and professional skill, but as time went on and the casualty lists grew, the general public grew disillusioned with the war. Writing about the Welsh Guards, who had deployed to Afghanistan from Aldershot in 2009, *The Times* reported:

> The death and injury of so many soldiers is affecting everyone - 12 [Welsh Guardsmen] have died since the start of the campaign in 2001, the vast majority this year, and many more have been wounded, some seriously.
>
> The wives and parents of the Welsh Guards comfort each other, sending text messages and speaking on the phone. Most of the relatives live in Aldershot, where the battalion is based, but their roots are scattered across Wales, where the sense of family and community is strong.

Among the casualties was Lieutenant-Colonel Rupert Thorneloe, Commanding Officer of the regiment and the most senior British officer to die since the Falklands conflict. His death 'knocked us for six,' said one of the soldiers' wives, 'If it could happen to Rupert, it made everyone feel a lot more vulnerable.'

The battalion returned home to Lille Barracks in October 2009 and a joyful reunion with their families. A 'Welcome home' parade through the town followed in December.

The band of the Welsh Guards leads the welcome home parade, December 2009.

Wearing their combat uniforms, the Welsh Guards march from Station Road into the High Street.

Homecoming and medal parades allowed Aldershot to express its support and gratitude for the soldiers' efforts. Typical was the parade for 101 Logistic Brigade on 16 June 2010, which began with a Memorial and Thanksgiving Service in the Royal Garrison Church of All Saints, a parade outside the Princes Hall when campaign medals were awarded and speeches made, and a march around the town centre behind the band of the Royal Logistic Corps. 'The general public turned out in large numbers to witness this homecoming march,' wrote one of the RLC in the *Aldershot Garrison Herald*, 'the reception bringing a tear to the eyes of some hardened long serving senior soldiers.'

Not all homecomings were so happy, and in the Aldershot Military Cemetery an area is set aside for recent deaths in service. This contains the graves of Rifleman Remand Kulung, who served with the 1st Battalion The Mercian Regiment, and died in August 2010 from wounds sustained in Afghanistan; Rifleman Suraj Gurung from 1st Battalion The Royal Gurkha Rifles, killed in Afghanistan during a foot patrol in October 2010; Lance Corporal Gajbahadur Gurung from the Royal Gurkha Rifles, serving with 1st Battalion The Yorkshire Regiment, killed in January 2012 in Helmand; Lieutenant Paul Mervis from 2nd Battalion The Rifles, killed in an explosion near Sangin in June 2009 and Corporal Kumar Pun of The 1st Battalion The Royal Gurkha Rifles, killed by a suicide bomb in Helmand in May 2009. All were buried with full military honours and their graves will be maintained by the Army in perpetuity.

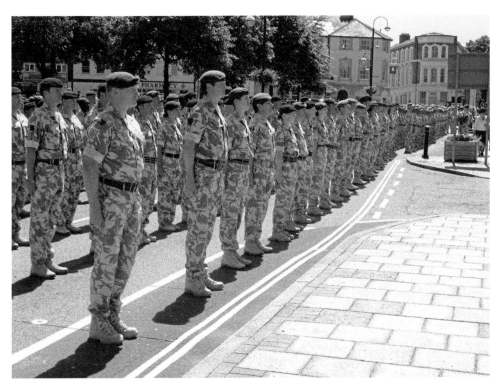

101 Logistic Brigade medal parade outside the Princes Hall, 2010.

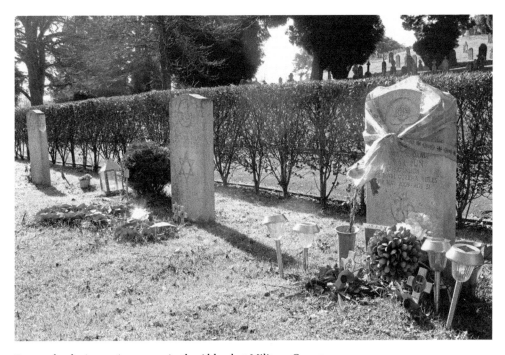

Recent deaths in service graves in the Aldershot Military Cemetery.

5. Military Personalities

As the largest and most important garrison in the country, many notable individuals have served in Aldershot.

The first General Officer Commanding (GOC) was appointed in May 1855, only a few weeks after the first units had taken up residence. This was Lieutenant-General Sir William Knollys, who commanded for five years. Knollys had previously served in the 3rd (later Scots) Guards, and was responsible for instructing the Prince Consort in military affairs. The camp lacked any administrative framework, so Knollys created his own staff and organised the troops into brigades and divisions, even giving personal instruction to some of the first arrivals on how to pitch their tents and in elementary fieldwork. On his departure in 1860, Knollys left Aldershot with an efficient organisation well capable of development.

Lieutenant-General Sir William Knollys. (AMM)

Knollys was subsequently made Comptroller of the Household of the Prince of Wales, a position he held until 1877 when he became Gentleman Usher of the Black Rod. He died on 23 June 1883 in Black Rod's House, Westminster Palace, aged eighty-five.

Knollys was followed as GOC Aldershot by Sir John Pennefather, who had commanded a brigade in the Crimean War, and who in turn was succeeded in 1865 by another Crimean veteran, Lieutenant-General Sir James Yorke Scarlett, who had commanded the Heavy Cavalry Brigade in the war. At the Battle of Balaclava, he had led his force of 800 men against 2,000 Russian cavalry, and drove the enemy off the field. Although Scarlett's 'Charge of the Heavy Brigade' was a great success, it was overshadowed by the disastrous 'Charge of the Light Brigade' later in the day. After the war Scarlett commanded the cavalry in Aldershot, until in 1860 he was appointed Adjutant General. He returned to Aldershot in October 1865 as GOC, and remained until he retired from active service in October 1870. He died in December the following year, aged seventy-two. A marble

Memorial to General Scarlett in the Royal Garrison Church.

memorial was erected to Scarlett in the Aldershot Garrison Church of All Saints, in the form of a bust of the general flanked by troopers of his former regiments.

One of the generals who had an immense impact on Aldershot was Lieutenant-General Sir Evelyn Wood, who began his service in 1852 as a midshipman in the Royal Navy, and served ashore in the Naval Brigade in the Crimea. Wood transferred to the Army, and while serving with the 17th Lancers during the Indian Mutiny he was awarded the Victoria Cross for extreme bravery at Sindwaha on 19 October 1858. After a period, as a staff officer at Aldershot, he was sent overseas again for the Ashanti campaign (1873–74), the Zulu War (1879), the First Boer War (1881) and the Egyptian War (1882).

Wood was appointed GOC Aldershot on 1 January 1889, where he introduced more modern training methods. He put an emphasis on field exercises, including night operations, and promoted better marksmanship among all soldiers. During his time at Aldershot, Wood gained a reputation as being one of the best trainers in the army. He was also largely responsible for replacing the old wooden huts with new brick barracks, and persuaded the War Office to allow him to name the new barracks after great British victories.

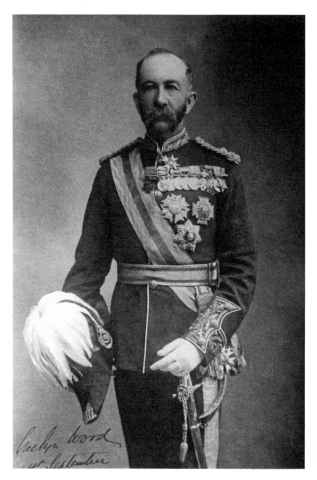

Lieutenant-General Sir Evelyn Wood, VC. (AMM)

In 1893 Wood was made Quartermaster-General, then Adjutant General and finally Commander of 2nd Army Corps. From 1911 until his death in December 1919 he was Constable of the Tower of London. Wood was buried in Aldershot Military Cemetery with full military honours.

At the end of the nineteenth century, Sir Redvers Buller, another VC holder, was appointed GOC. Prior to this he had served in the Peking expedition of 1860, the Red River Rebellion in Canada (1870), the Ashanti expedition, and the Zulu War. Buller was awarded the Victoria Cross during the Zulu War for his heroic rescue of three men from the enemy after the Battle of Inhlobane. He served in the first Boer War, the Egyptian campaign (1882) and the Gordon relief expedition (1885). During a period as a senior staff officer at the War Office from 1887 to 1897, he sponsored the creation of the Army Service Corps, in recognition of which the ASC barracks in Aldershot were named Buller Barracks.

Buller was appointed GOC Aldershot in 1898, but a year later he was made commander of the Field Force in Natal for the Second Boer War. After a series of setbacks Buller was released from command and returned to Britain. However, he never lost his popularity among the British people and when Buller returned to Aldershot, in January 1901, he was given a hero's welcome as huge crowds lined decorated streets to welcome him back. After retiring from active service in October 1901 he died in June 1908, aged sixty-eight.

In the early years of the twentieth century, three GOCs were appointed to Aldershot who would become prominent in the First World War. General Sir John French was GOC from 1902 to 1907, bringing with him a reputation as a trainer and an advocate of traditional mounted cavalry. In 1907 he was appointed Inspector-General of the Forces, and in 1914 was made Commander of the British Expeditionary Force (BEF).

General Buller (right foreground on the white horse) returns to Aldershot, 1901. (HCT)

Lieutenant-General Sir Horace
Smith-Dorrien. (AMM)

Lieutenant-General Sir Horace Smith-Dorrien followed French as GOC Aldershot from 1907 to 1912. He was a veteran of the Zulu War, Egypt, India, Omdurman and the Boer War, and in Aldershot he improved the quality and quantity of training, the living conditions of the soldiers and the camp's sports facilities, well appreciating the importance of sport for morale and physical training.

In the First World War, Smith-Dorrien commanded 2nd Corps of the BEF. He became famous during the retreat from Mons, when he ignored an order to withdraw and decided that 2nd Corps would make a stand at Le Cateau. Smith-Dorrien was frequently in conflict with his superiors, and in 1915 he was returned to Britain. In 1918 he was made Governor of Gibraltar, and was killed in a car accident in 1930, aged seventy-two.

From 1912, Lieutenant-General Sir Douglas Haig was GOC Aldershot. Born in 1861, Haig served in the Sudan, and was a Brigade-Major with the cavalry in Aldershot between 1898 and 1899. After service in the Boer War and a senior training role in India, he returned to take command at Aldershot.

On the outbreak of the First World War, Haig became commander of 1st Corps of the BEF (effectively the mobilised Aldershot Command) and from December 1915 to the end of the war he was Commander-in-Chief of the British Armies in France. The terrible loss of life during the war made Haig's actions the subject of fierce controversy, which continues to the present day. Haig died in London in 1928, aged sixty-six.

Two notable commanders of the Second World War who had close connections with Aldershot were General Wavell and General Auchinleck. General Archibald Wavell first

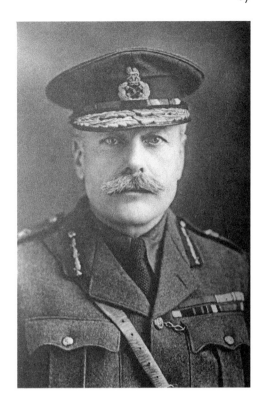

General Sir Douglas Haig. (AMM)

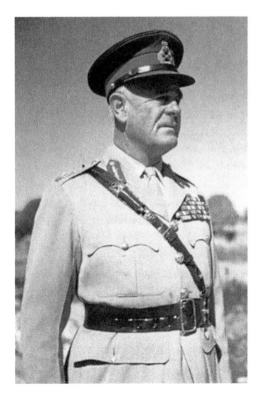

Field Marshal Archibald Wavell. (Alamy)

came to Aldershot in June 1930, when he commanded the 6th Infantry Brigade. He had served in the First World War, been wounded at Ypres and awarded the Military Cross. Wavell relinquished command of 6th Brigade in October 1933, but returned to Aldershot in March 1935 to command the 2nd Infantry Division. Wavell was recognised as an exceptional trainer of soldiers, and a creative and original military thinker.

Wavell left Aldershot in July 1937. In 1939 he formed the new Middle East Command, and secured a remarkable run of victories in the Western Desert in the winter of 1940–41. However, after the failure of his 'Battleaxe' offensive against Rommel, Churchill replaced him with Auchinleck. Wavell served in India as viceroy until 1947, and died in London in 1950. Today, Wavell has a high reputation as one of the best British generals of the Second World War.

Claude Auchinleck was born at No. 89 Victoria Road, Aldershot, on 21 June 1884. In the First World War he saw action in Egypt and Mesopotamia, was awarded the DSO in 1917, and was mentioned in dispatches three times. In the Second World War, Auchinleck's time as commander in North Africa was initially successful, driving the Germans back to Cyrenaica, but he was forced back by Rommel's counter-attack until, in July 1942, he finally stopped the German advance at El Alamein. Despite this, Churchill removed Auchinleck and replaced him with General Bernard Montgomery. Auchinleck went to India as Commander-in-Chief until independence in 1947. He died in Marrakesh in 1981.

When considering Aldershot's military history there are a further two people who were dedicated to preserving the rich heritage we have today. Lieutenant-Colonel Howard Cole,

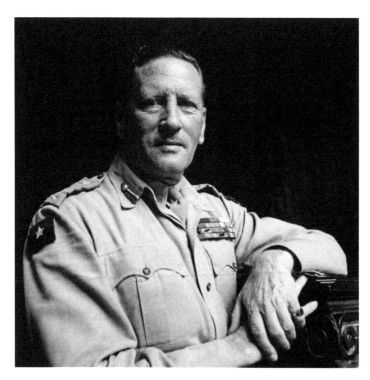

General Sir Claude Auchinleck. (Alamy)

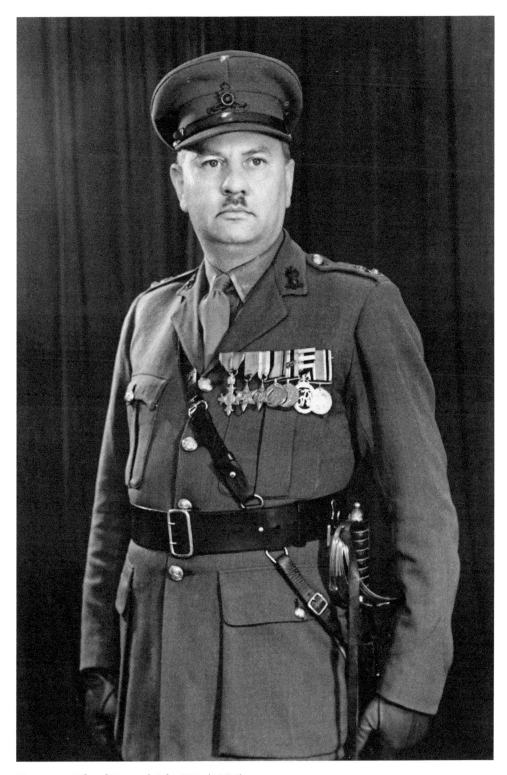

Lieutenant-Colonel Howard Cole, OBE. (AMM)

Brigadier John Reed. (AMM)

who gained the OBE in 1945 for services in north-west Europe, is still recognised as Aldershot's great historian and his book *The Story of Aldershot*, first published in 1951, remains a standard reference. Cole was appointed Honorary Remembrancer for Aldershot in recognition of his work. He died in May 1983, aged seventy-two, and is buried in the churchyard of St Paul's Church, Tongham. Howard Cole Way in Beaumont Park is named in his honour.

The second was Brigadier John Reed, who, following a distinguished military career with the Royal Engineers, was made Aldershot Garrison Commander from 1978 to 1980. Reed realised that there was a danger of all Aldershot's historic military buildings being lost, and he managed to stop the demolition of the last two Victorian barrack blocks in North Camp. When he retired from the Army, Reed founded the Aldershot Military Historical Trust and raised funds for the establishment of the Aldershot Military Museum, which opened in 1984 in the two buildings he had saved. Brigadier Reed died in February 1992, aged sixty-six, and at the museum the John Reed Gallery is named in his memory.

6. Buildings

Since Aldershot Camp was founded it has been rebuilt a number of times, each new camp replacing most of what has gone before. Indeed, the masterplan for the 1960s garrison called for the whole of the Victorian camp to be demolished. However, a handful of buildings from each era have survived, and most have now been given protection either as nationally listed buildings of historic interest, or locally listed by Rushmoor Borough Council.

Only one wooden building remains from the original camp, the guardroom of the Royal Pavilion. Built in 1856 for Queen Victoria, the Royal Pavilion itself was demolished in 1963 to make way for the Training Centre of the Queen Alexandra's Royal Army Nursing Corps, which in turn has been replaced by offices of the Computer Sciences Corporation. The guardroom, sited by the entrance off Farnborough Road, is used for seminars, training courses and meetings.

In retrospect it is fortunate that any parts of the first permanent barracks survived the post-Second World War demolition. Nothing remains of the 1850s infantry or artillery

The Royal Pavilion guardroom.

barracks, demolished between 1958 and 1961. The only remnants of Willems and Warburg cavalry barracks, demolished in 1964, are the Willems Barracks gates on the Wellington roundabout, and two stone tablets from the gates of Warburg Barracks mounted on metal frames by the Westgate, close to the original entrance to the barracks. Beaumont Barracks was demolished in the 1970s with a housing estate built on the site. Its only buildings to survive are the barrack gates and guardrooms on Farnborough Road, and the very elegant Riding School. The guardrooms are now used by the Beaumont playgroup and the Riding School, which was used by the Mounted Troop of the Royal Military Police until it was disbanded in the late 1980s, and has now been converted into offices.

With regard to the barracks built in the 1890s, in North Camp only two of the single-storey barrack blocks remain, M and N blocks of the old Oudenarde Barracks, which are now the central buildings of the Aldershot Military Museum. In South Camp the only survivors of the two-storey 1890s barracks are three blocks of McGrigor Barracks, opposite the Cambridge Military Hospital. Developers Grainger plc plan to retain two of the buildings for residential use, while a portion of the third may also be incorporated into the new design.

Two of the officers' messes from this period have survived. One in Lille Barracks, North Camp, is still used by the officers of the resident battalion, while Mandora Mess in South Camp, off Louise Margaret Road, is now used as business offices.

Another notable survivor is the fine Aldershot Command Headquarters building from 1895, with its attached buildings including the old South Camp Post Office and Military

The Beaumont Barracks Riding School.

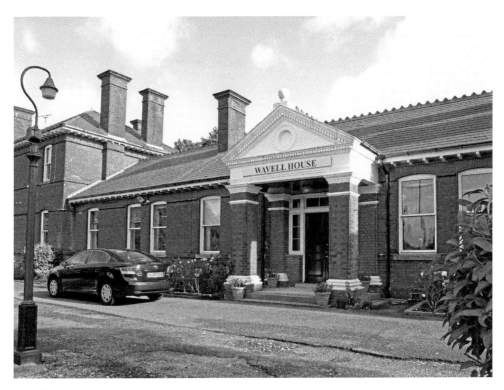

Wavell House.

Police Barracks, which will be retained within the Wellesley development, probably for commercial use. In North Camp, the old 2nd Division headquarters, built in the 1890s, was named Wavell House in the 1980s in honour of General Wavell, who had commanded 2nd Division from here in the 1930s. It is now part of the headquarters of 11 Infantry Brigade.

Of the barracks built between the two world wars, only some buildings of Clayton Barracks, built between 1926 and 1929, remain. Most of these will be demolished for the Wellesley housing estate, but it is hoped a couple of the better buildings will be converted into residential apartments.

As for the concrete barracks of the 1960s, most were swept away when the garrison was rebuilt at the beginning of the twenty-first century, but the Royal Army Dental Corps Centre still stands opposite the Aldershot Military Museum. In the area that was formerly Montgomery Lines, only a small guardroom building (originally designed as a band practice room) has escaped demolition, and it is hoped it will be retained within the civilian development.

When the Army arrived in Aldershot they established their first hospital in Union Building. Originally a sub-manor for the Tichbourne family, dating from the seventeenth century, it had been a workhouse and then a paupers' school. When no longer needed as a hospital it became the Army Pay Office, then latterly it was used as a families' centre until 2010, since when it has been converted into civilian apartments with the first occupants taking up residence in 2016.

Union Building.

The Army's magnificent purpose-built hospital opened in 1879 and was named after the Duke of Cambridge, the Commander-in-Chief. The Cambridge Military Hospital had a large central administration block, above which rose its clock tower, 109 feet high. Behind were six large pavilion wards running southwards off the main corridor, which was 528 feet (176 yards) long. Later expansion added smaller pavilion wards to the north side. Under the 1960s masterplan, the Cambridge was to be demolished and replaced by a new hospital in North Camp. After much delay and argument, the idea was dropped and the Cambridge survived into the 1990s when the building was declared to be no longer up to modern standards. Despite local protests – its facilities were extended to local residents – the Cambridge closed in March 1996. Work has now begun to convert the building into residential apartments.

Next to the Cambridge is the Louise Margaret Hospital, built in 1897 for the wives and children of the soldiers in Aldershot. From 1958 it became a dedicated maternity hospital for both military and civilian patients. The Louise Margaret closed in January 1995, and will also be converted to residential use.

The Connaught Hospital was opened in North Camp in 1898, and it treated wounded from the Boer War and both world wars. After the Second World War, the building was used as accommodation for miscellaneous units until it was declared unsafe. Although most of the building was demolished in the late 1980s, the elegant entrance block was retained and incorporated into the officers' mess of the new Normandy Barracks.

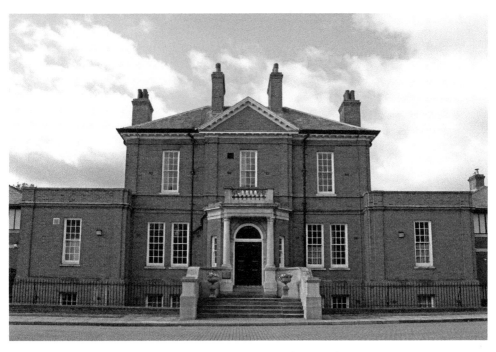

The entrance block of the Connaught Hospital in Normandy Barracks.

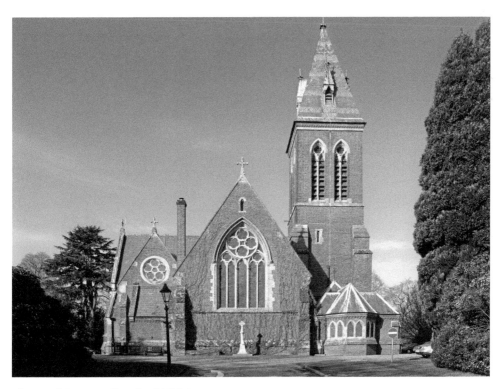

The Royal Garrison Church of All Saints.

Along with the permanent barracks it was decided that the great camp needed a suitable church. The Garrison Church of All Saints was accordingly built on Dolly's Hill and consecrated in 1863. On the occasion of its Diamond Jubilee in 1923 it was granted the title 'Royal' by George V. As a garrison church it contains many memorials dedicated to regiments and individuals who have served in Aldershot.

In 1892, Queen Victoria laid the foundation stone for a new church, the Church of St George, on Queen's Avenue. Originally another Anglican church, in 1973 it became the garrison Roman Catholic church, the congregation moving from the old wooden Church of St Michael and St Sebastian. The name of St Michael was added to that of St George, to give the church its modern title. In 1987, it became the cathedral church of the Roman Catholic Bishop of the Forces.

After the First World War there was a desire to build a new Church of Scotland as a memorial to the Scots who died in the war. The site chosen was that of the old 'Iron Church' on Queen's Avenue. The new church was opened in December 1927, although it was far from complete and further construction was carried out in the 1930s. The completed building was reopened on 12 January 1939 by George VI.

In the late nineteenth and early twentieth centuries, Aldershot became known for the number of 'soldiers' homes' established to provide recreational facilities for

St Andrew's Garrison Church of Scotland.

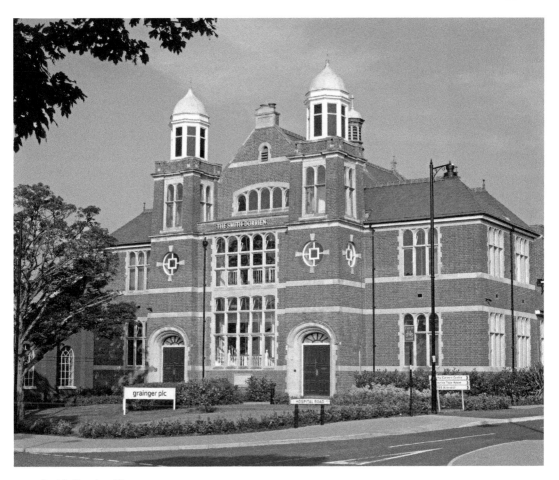

Smith-Dorrien House.

off-duty soldiers, free from what was regarded as the evil of alcohol. The first was founded in 1863 by Mrs Louisa Daniell and her daughter, Georgiana. Most of the original 'Miss Daniell's Soldiers' Home' was demolished in 1958, leaving only part of the main hall. In 1962, the Aldershot Freemasons took over this derelict building in Edward Street and renovated it for use as a Masonic hall.

The large Wesleyan soldiers' home in Grosvenor Road has now been converted to private residences. In Knollys Road stands the old Roman Catholic Soldiers' Institute, although the building is scheduled for demolition under the Wellesley development. The best preserved of the soldiers' homes is Smith-Dorrien House, which was built in 1908 as the Methodist Soldiers' Home. It is now used by Grainger plc, the lead developer for the Wellesley housing estate, who has restored the building to the elegance of its original design.

Next door to Smith-Dorrien House is Maida Gymnasium, built in the 1890s and the only building remaining from Maida Barracks. It is now used by a private fitness company. The Army retains the Fox Gymnasium on Queen's Avenue, which was built in 1894 and is still used by the Army School of Physical Training. Next to the Fox Gym is the original

Command Swimming Baths, opened in 1900. No longer used as a swimming bath, the building is currently awaiting conversion to a new use.

One of the oldest buildings in the garrison that is still used for its original purpose is the distinctive Prince Consort's Library in Knollys Road. Founded as a military library by the Prince Consort, it continues to support military training and education.

The Veterinary Hospital was built in 1858 to support the three cavalry barracks. Today, it is incorporated into the buildings of the Beaumont Village retirement housing development in Alexandra Road, which was opened in 2005 and sympathetically designed to retain historical integrity with the historic buildings. Aldershot's original Veterinary School was established in Gallwey Road by Major-General Sir Frederick Fitzwygram, an authority on the care of horses. Fitzwygram House is within the Wellesley area, currently awaiting conversion to residential use.

Finally, possibly the most unusual historic building within the area of the camp, and one of the smallest, is the observatory on Queen's Avenue. The building, and its telescope, were donated to the Army in 1906 by Patrick Alexander, a Fellow of the Royal Astronomical Society who lived in Mytchett. The observatory is still used by the Farnham Astronomical Society.

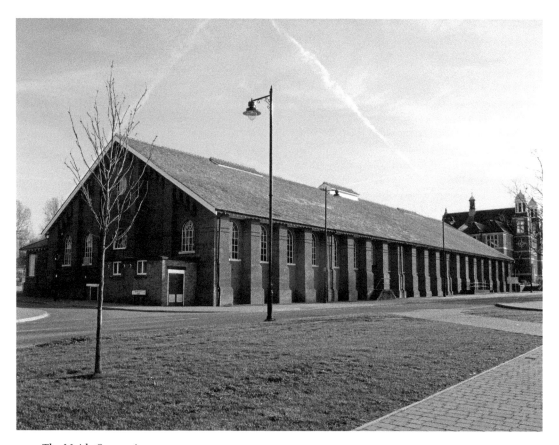

The Maida Gymnasium.

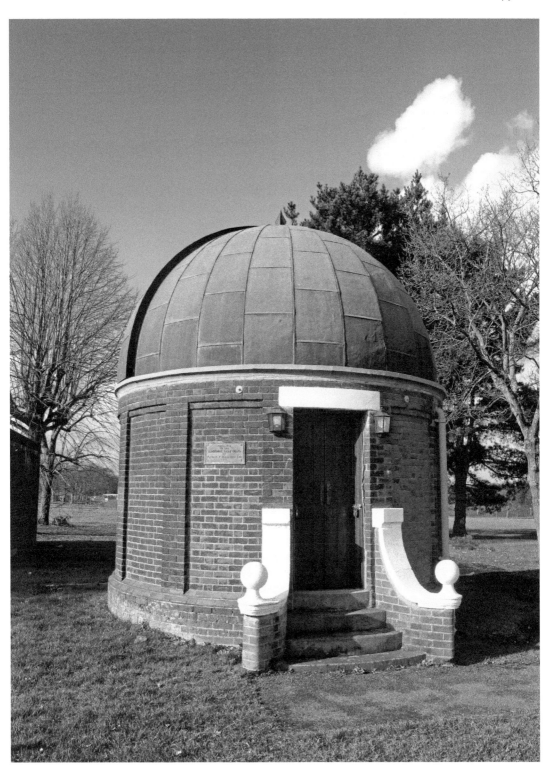

The Alexander Observatory.

7. Memorials

Soldiers from Aldershot who lost their lives while fighting for their country are remembered in numerous memorials in both the garrison and in the civilian town.

At the top of Gun Hill is a memorial remembering the men of the Royal Army Medical Corps who died in the Second Boer War in South Africa, 1899–1902. The fine central sculpture, of two men of the RAMC treating a wounded comrade, is by William Goscombe John. Above the sculpture is set a tall obelisk, and on the wall of the memorial are the names of 312 men of the RAMC who died in the war. It was unveiled by Edward VII on 'Empire Day', 24 May 1905.

The town's First World War memorial is a cenotaph made of Cornish granite, standing in the Municipal Gardens. It was funded by a public subscription, launched by the mayor in January 1924, which had raised over £1,100 by July (around £58,000 in present-day value). The memorial was unveiled on 18 March 1925 by the Duke of Gloucester following a short service of dedication.

The Royal Army Medical Corps' Boer War memorial.

In the camp, a memorial dedicated to the memory of the men of the 2nd Division who fell in the First World War was erected on a small knoll at the junction of Hospital Hill and Knollys Road. Second Division was one of Aldershot's resident formations and had mobilised from the camp in August 1914. The memorial was designed by Captain J. B. Scott MC, who had served with the division in the war, and is in the form of a stone cross set on a hexagonal base bearing the names of the divisional brigades and regiments. It was unveiled on 1 December 1923 by General Lord Horne and dedicated by Revd Hugh Hornby, who had served as a chaplain with 2nd Division from 1915.

In Queen's Avenue is the memorial to the men of the 8th Division who died in the First World War, a tall stone structure topped with a bronze lion. In 1922 General Francis Davies, who commanded 8th Division for much of the war, launched an appeal to erect a memorial to honour the men of the division who had died. A meeting of 8th Division veterans decided the memorial should be in Aldershot 'where it could be seen in years to come by the units which, during the Great War, belonged to the 8th Division'. The monument was unveiled by General Davies on 10 April 1924.

A memorial to the 1st Division stands in the south porchway of the Royal Garrison Church, a large wooden cross inscribed 'In memory of the Officers, SNCO's and Men of 1st Division killed in action near High Wood during September 1916 – RIP'. High Wood was the scene of some of the hardest fighting during the Battle of the Somme. After

Memorial to the fallen of 2nd Division in the First World War.

the battle, 23 Field Company Royal Engineers, the divisional engineers for 1st Division, constructed the memorial cross using wood taken from the ruins of Bazentin village. The cross was brought back to Aldershot after the war where it was erected outside the Divisional Headquarters in Pennefather's Road. However, as the cross was made from wood and exposed to the weather there was concern that it would not last.

In January 1939, when 23 Field Company Royal Engineers, successors to the men who had made the cross, were undertaking some reconstruction work to the Royal Garrison Church they moved the memorial from Pennefather's Road into the south porch. Now out of the wind and rain, the 1st Division cross still stands by the church entrance, a lasting and poignant memorial to the men who died at the Somme.

After the Second World War the Borough Council set up a War Memorial Committee with the aim of raising funds for a memorial hall. Rising costs meant that this object could not be achieved, but when the Princes Hall was built in 1973, the committee used its funds to lay out a Memorial Garden between the hall and Warburg car park. Plaques were set in this garden listing the names of Aldershot citizens who had died in the Second World War. When the area was re-landscaped in 2012 for the construction of the Westgate centre, the memorial was moved to a prominent position in front of the Princes Hall, where the Union flag flies constantly over the plaques bearing the names of the fallen.

The Somme Cross.

Aldershot's Second World War memorial by the Princes Hall.

In Manor Park is the remarkable Heroes' Shrine, a national memorial to all those killed in the Battle of Britain and in the 'blitzed' towns and cities. Mayors of thirty-four towns and cities that had suffered severe bombing raids each sent a stone from one of their war damaged buildings, which were set into two rockery gardens. A central figure of 'Christ stilling the storm' was sculpted by Josephina de Vasconcellos, and plaques in the walls recorded the towns and cities from where the stones came. The memorial was unveiled by the Duchess of Gloucester on 5 May 1950.

Outside the Church of St Michael and St George is a large arch dedicated to the memory of men of the Royal Army Service Corps who fell in both world wars. This was first erected in 1923 against the wall of the Headquarters of the RASC Training Centre in Buller Barracks, in memory of the members of the corps who had died in the First World War. After the Second World War, a second dedication was added to remember those who had fallen between 1939 and 1945. During the 1960s rebuild of Buller Barracks, the arch was set against a free-standing concrete wall, and when the RASC became part of the Royal Corps of Transport, another plaque was added remembering all who had died while serving in the corps since its founding as the Royal Waggoners in 1794. After Buller Barracks closed, the arch was moved in 2013 to the grounds of the Church of St Michael and St George, which had been known as the RASC 'Corps Cathedral'. In its new setting the arch is supported by some unobtrusive brickwork, and it has been set off by new walls, railings and planting.

During the time that Aldershot was the home of the Airborne Forces, a number of memorials were placed in Browning Barracks, mostly in the Memorial Garden created

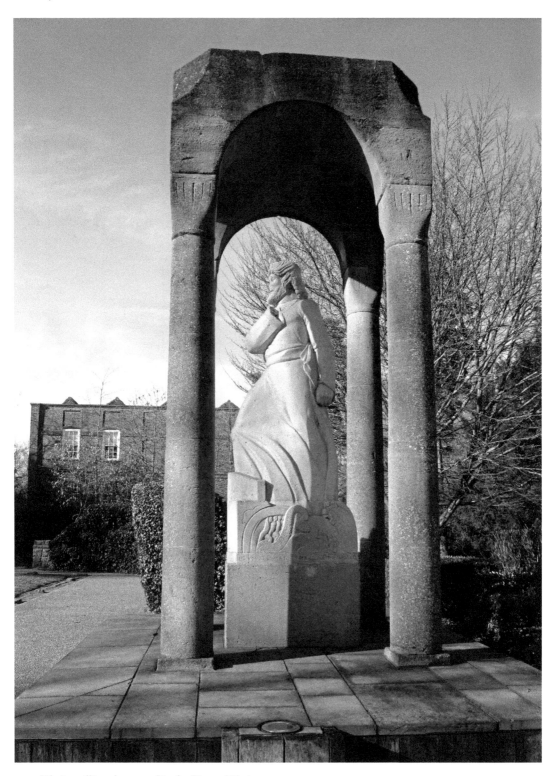

'Christ stilling the storm' in the Heroes' Shrine.

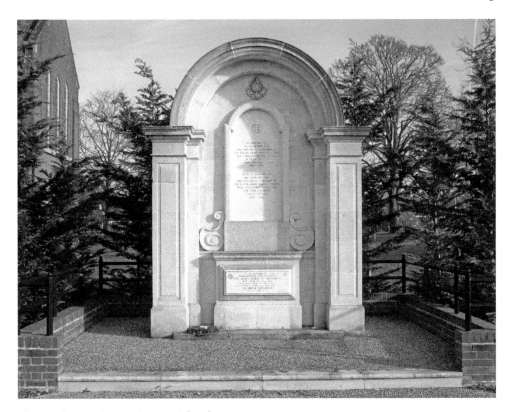

The Royal Logistic Corps' memorial arch.

for the 50th anniversary of the founding of the Parachute Regiment. When Browning Barracks was sold for civilian housing, the regiment decided that its memorials should be kept in a more appropriate setting. In 2007, a new monument was placed outside the Royal Garrison Church, made from a large piece of Purbeck stone onto which the memorial plaques from Browning Barracks were mounted. The new memorial was blessed in a ceremony on Remembrance Sunday 2007, in the presence of leading military and civic dignitaries. The memorial is surrounded on three sides by a small garden, and as a number of Airborne Forces veterans had had their ashes scattered in the Golden Jubilee Garden at Browning, a foot of soil from that garden was taken to the new location so that their ashes should still lay with the Airborne Memorial.

Towards the north end of Queen's Avenue is a large stone set in a small copse. This marks the site of the old Ramilles Barracks, and commemorates the founding of the Army Catering Corps there on 22 March 1941. The stone was unveiled on the corps' 50th anniversary in 1991.

There are also two memorials to individual courage in the military town. On Farnborough Road is a small stone drinking fountain dedicated to the memory of Captain Charles Beresford, of the Royal Engineers. On 30 May 1910, Beresford was riding with his troop on the Farnborough Road, when one of his men lost control of his horse. Beresford rode forward to stop the horse, which was endangering passers-by, and in the ensuing

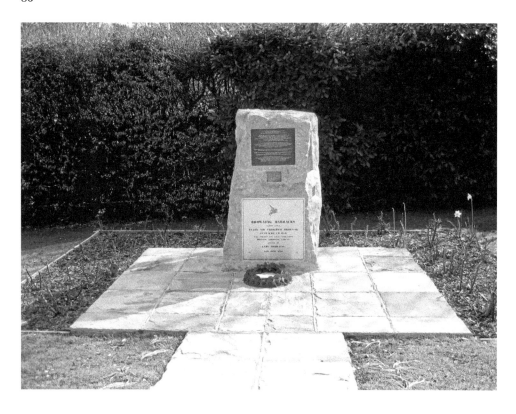

Above: The Airborne Forces' memorial.

Left: Beresford memorial.

collision both men were injured. The soldier suffered only minor injuries, but Beresford died from a fractured skull. Because of his selfless sacrifice, Beresford was given a full military funeral and was buried in the Aldershot Military Cemetery. Beresford's fellow officers subscribed to his memorial, which was placed near the spot where he died.

In Queen's Avenue is an obelisk dedicated to Lieutenant Reginald Cammell of the Air Battalion, Royal Engineers. Cammell was one of the Army's first test pilots, who was killed on 17 September 1911 when an aircraft he was flying from Hendon crashed. Cammell was buried in Aldershot Military Cemetery with full military honours, and the memorial was erected 'by his brother officers in recognition of his services to military aviation'.

Unquestionably the largest memorial in Aldershot is the great Wellington Statue, sited on Round Hill adjacent to the Royal Garrison Church. This was originally erected in London in 1846, where it was the subject of some controversy. It was moved to Aldershot in 1885 and handed over to the care of the Army by the Prince of Wales, who said that the statue of Britain's greatest soldier belonged in Britain's greatest army camp. At 28 feet high, and weighing 40 tons, it is still the largest equestrian statue in the country, and it has become the symbol of Aldershot's pride in its military heritage.

Cammell memorial.

8. Honours and Awards

Victoria Cross

The British Army's highest award for bravery in is the Victoria Cross, which is only given in cases of utmost courage in the face of the enemy. The only person born and raised in Aldershot to have been awarded the Victoria Cross is Alfred Maurice Toye (who preferred to be known as Maurice), born on 7 April 1897 in Stanhope Lines, and educated at the Aldershot Garrison School. At the start of the First World War, Toye served with the Royal Engineers until being commissioned into the Middlesex Regiment in 1917. In October that same year he won the Military Cross in the fighting for Passchendaele.

During the German spring offensive of 1918, Captain Toye's company was defending a bridgehead near Eterpigny, on the River Somme. On 21 March they were surrounded by a large German force, when Toye took the initiative and broke out with one officer and six men. He found seventy men of the Durham Light Infantry, rallied them and led a counter-attack that was so effective that the German advance around Eterpigny was

Captain A. Maurice Toye. (PCL)

checked. When relieved, Toye's company was reduced to only ten survivors. A few days later, Toye led a group of soldiers through an occupied village under heavy fire. Despite being wounded twice, he charged the enemy firing rapidly, and led his men out of danger. Captain Toye's VC citation records his 'most conspicuous bravery and fine leadership displayed in extremely critical circumstances'. He was invested with his medal by George V on 8 June 1918 during a ceremony on Queen's Parade, Aldershot. In a quite momentous week, Maurice Toye was married five days later in the parish church of St Michael.

Toye continued to serve in the Army until after the Second World War, before leaving in 1949 in the rank of brigadier. He was then Commandant of the Home Office Civil Defence School until illness forced him to retire. He died in 1955 at Tiverton, Devon, aged fifty-eight.

Although Maurice Toye is celebrated as Aldershot's own VC hero, the town has close connections with some other holders of this highest honour. Thomas Peck Hunter, the only Royal Marine to have been awarded the VC in the Second World War, was born in the Louise Margaret Hospital on 6 October 1923. His father was a Lance-Sergeant with the 2nd Royal Scots, who were stationed in Aldershot at that time. While Thomas was still a baby they returned to Scotland and he grew up in Edinburgh until he joined the Royal

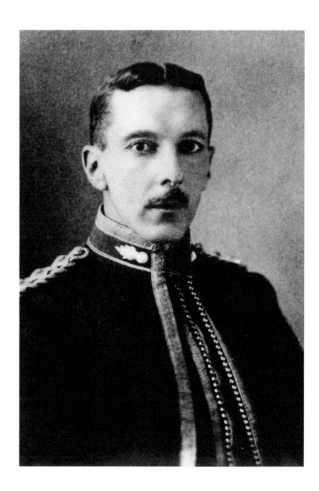

Captain Ernest Alexander. (PCL)

Marines in 1942. Corporal Hunter was posthumously awarded the Victoria Cross for his courage at the Battle of Argenta Gap on 2 April 1945.

In September 1903, Captain Ernest Alexander married Rose Newcombe, of Aldershot Manor. Alexander, who was born in Liverpool in 1870, had been commissioned into the Royal Artillery in 1899, and since 1900 had been stationed with his battery in Aldershot. Less than a month after his wedding, Alexander was posted overseas, and at the start of the First World War, now a major, he was sent to France. On 24 August 1914, at Elouges, Alexander's battery was attacked by overwhelming numbers of Germans, but by his courage and skill he managed to save all his guns. For his gallantry, Alexander was invested with the Victoria Cross in July 1915. In 1919, he returned to Aldershot as commander of the Royal Artillery, Southern Area, until he retired from active service in 1920 and moved to Devon. Alexander died in 1934, aged sixty-three.

Three holders of the Victoria Cross are buried in the Aldershot Military Cemetery. Field Marshal Sir Evelyn Wood's remarkable career has already been discussed. An inconspicuous grave near the Cemetery Chapel marks the burial place of William Davidson Bisset, a native of Perthshire, who was awarded the VC during the First World War while serving with the 1/6th Argyll and Sutherland Highlanders. On 25 October 1918, in an area east of Maing, Lieutenant Bisset led two bayonet charges on enemy positions under heavy fire, which succeeded in driving back the enemy. Bisset was demobilised in 1919 but returned to the Army at the start of the Second World War, when he served in the Royal Army Ordnance Corps before transferring as a major to the Pioneer Corps, finally being demobilised in 1946. Bisset died in Wrexham in 1971, where he was cremated and his ashes brought to Aldershot for burial.

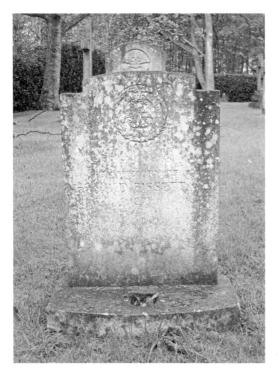

The grave of Major William Bissett, VC.

The grave of Sergeant Ian McKay, VC.

In the Falklands plot of the Military Cemetery is the grave of Sergeant Ian McKay of the 3rd Battalion, Parachute Regiment. In 1982, McKay deployed with his battalion from Aldershot to the South Atlantic. During the night of 11/12 June 1982, 3 Para was attacking enemy positions on Mount Longdon, when McKay's platoon commander was wounded. Sergeant McKay took command and led the platoon in a gallant attack under heavy fire against an Argentinian position. Disregarding his own safety, McKay charged the position alone and destroyed it with grenades, allowing two other platoons to deploy with relative safety. At the moment of victory, Sergeant McKay was killed. For his bravery, he was posthumously awarded the Victoria Cross.

Freedom of the Borough

The greatest honour a town can bestow is the granting of the Freedom of the Borough. The first army unit to be given the Freedom of Aldershot was, appropriately, the Hampshire Regiment in recognition of the regiment's distinguished history, close association with Aldershot and its actions in the Second World War. The ceremony took place on 11 September 1945 in the Recreation Ground. The 'Aldershot News' described the scene:

> Immaculately turned out, marching with dignity and precision, they strode onto the parade ground. Louder and louder grew the volume of applause and, assuming their allotted position, the ceremony took place. In a speech read in elegant tones by the Town Clerk, the deeds of the Hampshire Regiment were unfolded and feelings of pride in their County Regiment were augmented in the hearts of everyone as they listened to this remarkable chapter of history.

After receiving their Freedom, the regiment marched through the town, exercising its new rights to parade 'with drums beating, colours flying, and bayonets fixed'.

Later that same month, on 26 September 1945, Aldershot's wartime visitors were honoured as the Canadian Army Overseas were also made Honorary Freemen in another ceremony at the Recreation Ground.

Over the next three decades the Freedom of Aldershot was conferred on other units with a close association with the town, starting with the Parachute Regiment in 1957, for whom the Freedom scroll recorded that 'the closest ties of lasting friendship between the Borough of Aldershot and the Parachute Regiment have been forged and the civic life of the Borough ... has been enriched by the presence of the Regiment'. Three years later, the Army Physical Training Corps was honoured on the occasion of the centenary of their founding in Aldershot as the Army Gymnastic Staff. The honour was also conferred on the Corps of Royal Engineers (1965); the Royal Corps of Transport (1970); and the Army Catering Corps (1971). The last units to receive the Freedom of Aldershot were the Army Medical Services, comprising the Royal Army Medical Corps, the Royal Army Dental Corps and Queen Alexandra's Royal Army Nursing Corps in 1973.

In 1974, Aldershot joined with Farnborough and Cove to create the new borough of Rushmoor. To continue the honours from the old borough of Aldershot under the new

Freedom parade of the Hampshire Regiment. (RHR)

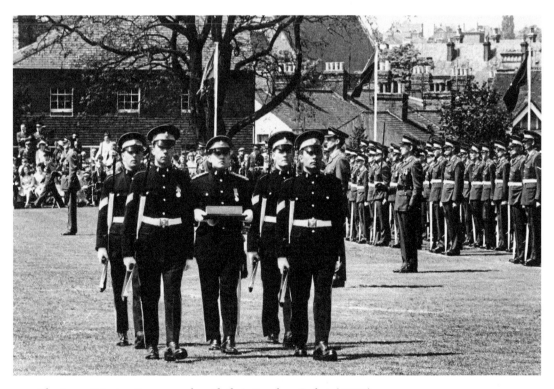

The Army Catering Corps parade with their Freedom Casket. (AMM)

local authority, on 29 May 1981 all the regiments and corps that had enjoyed the Freedom of Aldershot were admitted as Honorary Freemen of Rushmoor.

The new borough continued to honour military formations that had a long association with Aldershot. The Corps of Royal Military Police, whose origins go back to 1855 when a new unit was created 'as a Corps of Mounted Police for the preservation of Good Order in the camp at Aldershot and for the protection of the inhabitants of the neighbourhood', was admitted in 1984. Similarly honoured were the Royal Regiment of Artillery (1986); the Royal Air Force, Farnborough (1988); the Royal Army Veterinary Corps (2004) and most recently 10 The Queen's Own Gurkha Logistic Regiment in 2016.

The importance of the Freedom of the Borough for both the town and the Army was best expressed in the programme of the ceremony for the Hampshire Regiment in 1945, which said:

> The Freedom of Aldershot is not the freedom of an ancient town, but it is the highest tribute which the foster-mother of the British Army for nearly a hundred years can offer to her sons and their county brothers, and she bestows it with deep pride, affection and gratitude, feeling that in reality it is she who is honoured by the Regiment's generous acceptance.

The military have been a major element in the life of Aldershot for over 160 years, and the town is still proud to be 'the Home of the British Army'.

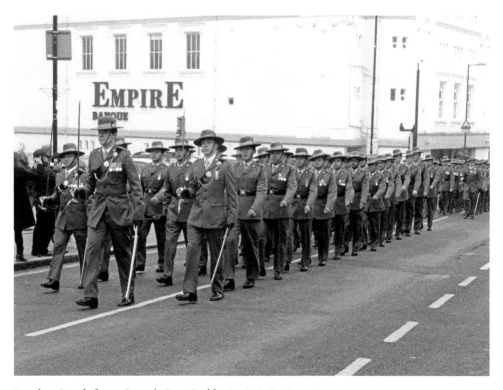

Freedom Parade for 10 Queen's Own Gurkha Logistic Regiment.

Acknowledgements

Much of the primary source material for this book is from the National Archives, Kew, the archives of the Aldershot Military Museum, and the Royal Hampshire Regiment Museum. I am very grateful to the curators and staff of the museums for all their assistance. For published sources, I have been privileged to be allowed to use the outstanding resources of the Prince Consort's Library, Aldershot, and I thank the librarian and staff for all their help. The Aldershot Public Library also has a fine collection of local material, and the staff are always very helpful.

For use of images I am grateful to: the Aldershot Military Museum (AMM), Prince Consort's Library (PCL), Hampshire Cultural Trust (HCT), Royal Hampshire Regiment Museum, Winchester (RHR), Brian Ballard (BB), Peter Smith (PS), the Brown Digital Repository (BDR) and Alamy Ltd. All other pictures are from the author's collection.

For their invaluable help with the text I am grateful to author and historian Peter Reese, and retired librarian Martin Rickard. Finally, my thanks to Amberley Publishing for their continuing confidence in publishing books on Aldershot history.

About the Author

Paul Vickers has had a lifelong interest in military history and has studied the history of Aldershot Camp since moving to the area in 1983. He was elected vice-chairman of the Friends of the Aldershot Military Museum when the Friends were founded in 1987, and served as chairman for fifteen years. Professionally he worked for the Army Library and Information Service for thirty-six years. He is a Fellow of the Chartered Institute of Library and Information Professionals. Other interests include model soldiers, and he is currently the president of the British Model Soldier Society.

Other books by Paul Vickers include *Aldershot History Tour* (Amberley Publishing, 2016); *Aldershot Through Time* (Amberley Publishing, 2012); *A Gift So Graciously Bestowed: The History of the Prince Consort's Library* (Friends of the Aldershot Military Museum, second edition, 2010); *Multum in Parvo: the British Model Soldier Society 1935–1995* (BMSS, 1995); and he was editor and joint author of *Rushmoor Remembers: Aldershot, Farnborough and Cove in the First World War* (Friends of the Aldershot Military Museum, 2014).

Paul H. Vickers